Roland Penrose

PICASSO

Phaidon

The plates in this volume have been selected
by the Publishers

Phaidon Press Limited, 5 Cromwell Place, London SW7

Published in the United States by Phaidon Publishers, Inc
and distributed by Praeger Publishers, Inc
111 Fourth Avenue, New York, N.Y. 10003

First published 1971
Second edition 1972

ISBN 0 7148 1536 5
Library of Congress Catalog Card Number: 70-141064

Printed in Great Britain
Text printed by R. & R. Clark Limited, Edinburgh
Plates printed by Jarrold & Sons Limited, Norwich

PICASSO

THE NAME which predominates in the development of the arts during this century, and to which the most revolutionary changes are inevitably ascribed, is that of Pablo Picasso. It is, moreover, largely due to him that the conception of art as a powerful emotional medium, rather than a search for the perfection of ideal forms of beauty, has become accepted among the artists of our time. The return to a fundamental belief that art should spring from a primitive need to express our feelings towards the world around us in strong emotional terms makes us more prone to value a work of art for its vitality than for its perfection. It is the exceptional power of Picasso's work that compels us, in return, to discover in it the mysterious presence of beauty.

Early in life doubt, and dissatisfaction with academic formulas, brought him to discover that a search for beauty according to the standards in which he had been brought up was not the aim he wished to pursue. The brilliance of his talent as a youth and the ease with which he absorbed the work of other great contemporary artists could have tempted him to become satisfied with the success that came to him at last after years of poverty in Barcelona and Paris, but the strength of his powers of expression coupled with an unusual degree of courage brought a crisis which forced him to abandon the easy road to fame and plunge perilously into new forms of creation.

The turning-point in Picasso's early career came when he was 25. The struggle in which the young artist found himself involved is forcibly illustrated in the great picture, *Les Demoiselles d'Avignon* (Plate 16), painted in Paris in the spring of 1907. It came as a shock to his friends that he should abandon a style that they had grown to love and produce instead a form of art that they could no longer understand. No one, not even Matisse, Braque and Derain, nor his devoted patrons, nor even his close friend and admirer Guillaume Apollinaire could stomach this work, which at first sight seemed to them outrageous. It took many months to digest this insult to their sensibility, but gradually they came not only to accept it but to find that it was exerting a profound influence on them. Apollinaire, when he realized the significance of the change that had taken place in the artist as well as in his work, wrote a description of the difference between two kinds of artists: those who follow their impulses and show no signs of struggle, who 'are like a prolongation of nature' and whose works 'pass in no way through the intellect', and other artists who, in solitude, 'must draw everything from within themselves'. 'Picasso', he states, 'was an artist of the former kind. Never has there been so fantastic a spectacle as the metamorphosis he went through in becoming an artist of the second kind.' (Guillaume Apollinaire, *Cubist Painters* [English trans.], New York, 1944.)

This courage to explore the unknown, which has never forsaken Picasso, led in the years that followed to the creation of a new style, cubism (Plates 16–25). Working in close collaboration with his friend Georges Braque, he was responsible for one of the major revolutions in the art of our time, a revolution which revised the relationship of painting to reality and widened the scope of our vision and our understanding of the world. Although since that time the work of Picasso has not always been cubist in style, the discoveries made between 1909 and the outbreak of the 1914 war (which ended his close association with Braque), have led to innumerable developments in his work and have spread their influence more widely than any other single movement in the arts. One of the main characteristics of his work is the ease with which he can vary his style and often mingle styles which might seem incompatible in the same painting. This tendency has in fact increased as time has passed and his experience in the various forms of expression

which he employs has grown richer. In his career it is remarkable how little of his former discoveries is lost. A visual memory of prodigious accuracy enables him to hold years of experience at his disposal, and contributes to the speed and urgency with which he is able to work. This retentiveness does not apply only to technical discoveries. He has been preoccupied throughout his life by images and events that possess a peculiar significance for him. The enveloping tenderness of maternity, the wonder of the human head (Plates 8, 9, 15, 20, 29, 36, 41), the dilemma of the artist in relation to his model (Plate 48), the sacrificial drama of the bullfight, the heroism of classical myths, metamorphoses among living beings and inanimate objects, the breadth and luminosity of landscapes or the familiar domesticity of a still life (Plates 22, 23, 42, 43): these themes have always absorbed him.

Although Picasso has lived by far the greater part of his life in France he has never forgotten his Spanish origins. Born in Malaga in 1881, he was the son of José Ruiz Blasco and Maria Picasso Lopez. He received his first instruction in the arts from his father who was a mediocre painter but who had the virtue of encouraging his son and who realized that the boy's talent, at the age of 13, already greatly surpassed his own. After early training in the academic tradition at art schools in Corunna, Barcelona and Madrid, where he passed his entrance examinations brilliantly, he rapidly outgrew the instruction that these academies were able to offer. Barcelona, where his family had settled, proved to be too provincial an atmosphere for him and he sought the more brilliant international stimulus of Paris. Even so, the habits, the temperament, and the art of Picasso are still fundamentally Spanish, and the early influences absorbed by him are not limited to the discoveries he made in Paris but spring also from the art of his native land.

Picasso's faithfulness to the country from which he has exiled himself is an example of the many paradoxes which are characteristic of his life and his work. For instance, he can convey with extraordinary tenderness the intimacy of lovers (Plate 26) and yet submit the female form to a scathing visual analysis (Plates 9, 16, 17, 44). There seems to be no limit to the distortions he can invent for the human body (Plates 19, 31, 33, 35, 44) and yet no artist has more compassion for human anguish. He is a revolutionary who understands and loves tradition, and a creator so essentially concerned with life that he is often obsessed by the grim reality of death. Novelty and invention fascinate him as they do a child, but there is also a continuity which runs throughout his work, giving it the constant imprint of his genius. His capacity to invent new styles and techniques, a gift that has often bewildered both his admirers and his critics, is not a fickle disregard for his former loves, it is rather a means of saving himself from the sterility of repetition, and keeping us perpetually astonished at the youthfulness and penetration of his vision.

The output which has come from Picasso's untiring energy is prodigious. It is inconceivable owing to its sheer volume that the majority of his most important works in painting alone could be combined in one exhibition. Although painting is his major art, the universality of his genius extends to sculpture, drawing, etching and ceramics (Plates 46a and b, 47a), murals and designs for the theatre, poetry, the writing of plays, and the cinema. His enormous influence on the art of our time is due to the vigour and the lack of prejudice with which he develops these diverse means of expression. No artist can afford to ignore him and those who have found inspiration in his work are countless. No contemporary style, from surrealism or expressionism in their various forms to the most unemotional geometric abstraction, escapes his influence and in innumerable cases he is the prophet and the forerunner of new trends.

The work of Picasso is more than a mirror of our times; it opens our eyes to the future. Its vitality and its insight, its tenderness and its violence, are born of an understanding and a love for humanity. His art goes far beyond a facile enchantment of the eye. It fulfils a more essential purpose – the intensification of feeling

and the education of the spirit. Picasso looks at the world with new vision, and by his art he enables us to do likewise.

1895–1901: *EARLY YEARS*

During his early childhood in Malaga Picasso showed an overwhelming desire to express himself by drawing and painting. He was encouraged by his father who earned a modest living as an artist and teacher of art. Paintings made in Corunna at the age of 14 show extraordinary accomplishment and a year later he began to find his place among the artists and poets of Barcelona, immersed in a *fin de siècle* atmosphere. His early dedication to the arts combined with his unusual talent led Picasso to explore wider fields and seek new influences. These he found in Paris. In 1900, the year of his first visit, he was deeply impressed by the Parisian verve of Toulouse-Lautrec, the exoticism of Gauguin and the powerful expressionism of Van Gogh (Plates 1–3). With eagerness and insight he readily assimilated what appealed to him in their styles without forgetting what he had learnt in his native country from El Greco, Velazquez and Goya. His return to Barcelona, where his family helped to alleviate his painful struggle against poverty, kept alive the Spanish elements in his work.

1901–4: *BLUE PERIOD*

During his visit to Paris in 1900 Picasso had found inspiration chiefly in the bright colour and the gay bourgeois life seen in cabarets, public gardens and on the race-course. On his return in the spring of 1901, after a few months in Madrid, his mood had changed and an element of melancholy, intensified by pervading cold ethereal blue tones, began to dominate his work (Plates 4, 6–9). The subject matter was chiefly drawn from vagabonds, beggars and prostitutes, the victims of society who frequented the bars of Montmartre or the streets of Barcelona. The greater part of these years was spent in Barcelona, where he found daily in the streets the pathetic figures of blind beggars (Plate 4) or poor women bowed compassionately over their children. Allegories concerning poverty, blindness, love, death and maternity were often in his thoughts (Plates 6, 7), particularly when he was working on large compositions, and the figures, more sculptural in form than in the previous period, are given dramatic emphasis by the simplicity of their backgrounds. It has been said that at this time he was influenced by the Catalan painter Nonell. The Blue period marks a deliberate step towards a plastic representation of form and emotional subject matter and hence away from the atmospheric effects of the Impressionists.

1904–6: *SALTIMBANQUE AND ROSE PERIOD*

In 1904 Picasso finally moved to Paris. He took a studio in the *Bateau Lavoir*, a building inhabited by painters and poets, high up on the slopes of Montmartre. The more spirited and bohemian characters of his new friends, and the company of the beautiful Fernande Olivier, led him away from the melancholy subjects which had obsessed him during the Blue Period. With frequent visits from Max Jacob, Apollinaire and Salmon his studio became known as the '*Rendezvous des Poètes*'. It was here that the famous banquet in honour of the Douanier Rousseau took place in 1907.

The paintings of the Blue period had at last begun to sell to dealers and collectors such as Gertrude and Leo Stein (Plate 15), Wilhelm Uhde, and the Russian, Shchukine. The actors and strolling players of the boulevards and circuses became his friends and found their way into his paintings in tender nostalgic association (Plates 5, 11, 12). Harlequin, who had always been a favourite character in Picasso's imagination, made frequent appearances in his compositions, often figuring as a portrait of the artist himself. The predominant blue of the preceding year gave way to gentle tones of pink and grey.

The paintings of 1904 are often recognizable by elongations of the limbs that recall the mannerist style of El Greco, but by 1905 Picasso had abandoned these distortions for a classical purity of proportion. This in turn gave way to an insistence on sculptural qualities with a predominant emphasis on volume.

During these years Picasso paid a brief visit to Holland (Plate 10). He spent the summer of 1906 at Gosol, in the Pyrenees, where he painted many portraits, studies of Spanish peasants, and compositions. On his way to Gosol he had paid a visit to his family in Barcelona and refreshed his memories of the Romanesque and Gothic art of Catalonia. Even more important to him at this time was the discovery of Iberian sculpture dating from pre-Roman times, examples of which had been recently acquired by the Louvre. They attracted him by their unorthodox proportions, their disregard for refinements and their rude barbaric strength. These influences rapidly gained an important place in his work, and led to the sculptural distortions of nudes painted on his return to Paris in the autumn of 1906. During these years Picasso produced his first pieces of sculpture (*The Jester*, 1905; *Head of Fernande*; *Girl combing her Hair*, 1906, etc.), also a remarkable series of etchings (*The Frugal Repast*, 1904; *The Saltimbanques*, 1905; *Salome*, 1905, etc.).

1907–9: *TRANSITION – THE NEGRO PERIOD*

During the summer of 1906 Picasso met Matisse at the house of Leo and Gertrude Stein. Matisse had been acclaimed as the leader of the Fauve movement and his great picture, *La Joie de Vivre,* had been exhibited that spring at the *Salon des Indépendants.* Picasso, who at that time refused to exhibit in large group exhibitions, was nevertheless highly conscious of the revolutionary violence in the paintings of the Fauves, and held Matisse, Derain and Braque in great esteem. However, their tendency to insist in their work on the sole importance of colour appealed to Picasso no more than did the search for representation of atmospheric effects practised by the Impressionists. At the same time there were other influences at work. The painting of Cézanne had become familiar to him through the dealer Ambroise Vollard who had given him his first exhibition in Paris in 1901. Cézanne's search for a valid interpretation of form and the geometric basis of his compositions had impressed the young Spaniard who desired to create a tangible, three-dimensional quality in his painting. Picasso had also discovered the greatness of an obscure old man, the Douanier Rousseau, the fresh vitality of whose work corresponded to Picasso's desire to discover new forms of expression. These were the years when the power of primitive art imported from Africa and the South Seas was beginning to be noticed by certain painters in Paris, and styles which had formerly been despised as barbaric began to be recognized as possessing great emotive strength.

On his return from Gosol in the autumn of 1906, Picasso had continued to emphasize and simplify form, especially in his paintings of nudes (Plate 13); but it was not until that winter that he was to start work on a large canvas which was to be a turning-point not only in his own career but also in the history of contemporary art. In the same spring he had painted *The Harvesters* (New York, Private Collection), a picture which shows more than any other a use of colour similar to that of the Fauves and also a desire to create movement in a composition. Both these tendencies were used in this case at the expense of a more penetrating sense of form. But in the great picture *Les Demoiselles d'Avignon* (Plate 16), his aim had changed. Colour was strictly limited to pinks and blues and forms became clearly defined and static. For many months he had prepared great quantities of studies and he continued his ideas in 'postscripts' long after the painting had been left unfinished. This painting became the testing-ground for doubts that had troubled him. With a courage which greatly perturbed his friends, he sacrificed all the charm, bordering at times on the sentimental, which had built up an early fame. In his search for more powerful forms of expression he had become

conscious of the vitality of primitive art and his recent visit to Catalonia had renewed his desire to recapture at all costs its fundamental qualities. The result was a great picture which was greeted by cries of horror from his most enlightened friends and which, although left rolled up in his studio for more than twenty years, was nevertheless to become an overwhelming influence in the future.

The period which followed *Les Demoiselles* began with paintings which developed out of the treatment of the two figures on the right of the painting. Their similarity to African sculpture, which had that year become one of Picasso's sources of inspiration, has led to the adoption of the term 'Negro period' for the months that followed. The new style depended in particular on a simplification of form and a clarification of the methods by which it was depicted. With a disregard for classical tradition, distortions were used freely to emphasize volume and convey emotional sensation. Picasso applied his discoveries with great consistency to all the subjects that presented themselves to him: the human form, flowers, landscapes, portraits or still life.

In the summer of 1908 Picasso spent a few weeks in the country north of Paris, using his new style to paint landscapes. On his return he was surprised to find that Braque, with whom his friendship had begun a year earlier, had also independently followed a similar course in the south of France. It was these paintings by Braque which were first given the name 'cubist' by the critic Vauxcelles when they were exhibited a few months later.

During the following summer, at Horta de San Juan, Picasso developed the principles of his new style still further. The clear-cut rocky landscape gave him the opportunity to pursue Cézanne's recommendation that nature should be considered in terms of the cylinder, the sphere and the cone, a principle which he applied with equally astonishing results to portraits and to still life.

1910–12: *ANALYTICAL CUBISM*

'I paint objects as I think them, not as I see them.' This remark made by Picasso to the poet Ramon Gomez de la Serna explains the essential divergence between Picasso and Cézanne. The latter had drawn his inspiration primarily from his immediate visual reaction to the objects before him. Picasso was increasingly drawn to making creations according to his own internal vision. In African art he had found a conceptual art which, in the same way, was not based on immediate visual reactions to a model. The original impact had been violent. It had forged the first real link between African art and Western ideas and it was followed during the two years that succeeded the painting of the *Demoiselles d'Avignon* by a growing tendency to bring order into these first impulses.

In close association with Braque, 'roped together like mountaineers', as Braque expressed it, Picasso began to clarify and systematize a new conception of the painter's experience. In order to understand form and interpret its existence on a flat surface they felt it necessary to break into the form, separate its elements, penetrate beneath the surface and become conscious of that which cannot be seen because accidentally it is at the back of the object in question. The appearance of an object taken from one point of view was manifestly insufficient. It should be conceived from all angles (Plates 19, 21). They painted what they *knew* to be there. To do this effectively certain limitations seemed desirable. For a time both Braque and Picasso severely limited their palettes to sepia and grey with the occasional intrusion of an olive-green or ochre. Secondly, the traditional rules of linear perspective were completely abandoned, and modelling in the round gave place to flat crystalline facets which, built up together, gave the appearance of solid form (Plates 18, 19, 20, 21). The system depended also on a close relationship between the figures or objects and their background. A sense of homogeneity throughout the picture was created by uniting the background closely with the objects so as never to allow a rift to appear between them. Each facet overlaps or touches its neighbour, giving an appearance both of a solid architectural construction and of

the translucence of crystal. The fervour with which the two creators of cubism developed their discoveries led them into a language of abstractions. Their work became more purely conceptual and increasingly detached from normal visual appearances (e.g., Plate 20). For a while they preferred not even to sign their works, so as to give them a sense of detachment, even impersonality; as a result it is sometimes not easy to distinguish between their work at this period.

It would be a mistake, however, to see in these works purely impersonal abstract design. In every case they are based on the conception of some definite object, as well as the personality of the artist. Clues are always to be found. A symbolic moustache gives the clue to the face in which it may be the only recognizable feature. The curve of a guitar or the stem of a glass is a guide to the identity of objects that have been shattered and rebuilt as an integral part of the picture. The eye as it travels over the picture finds itself above, behind, and in front of the object at the same time, but the movement is in the consciousness of the spectator rather than in the object itself. All these varied aspects are woven together into a new realization of the totality of the object.

1912–16: *SYNTHETIC CUBISM*

In their enthusiasm during the first heroic years of cubism, Picasso and Braque carried this style, which had metaphysical as well as visual significance, to a degree of purity which threatened to make it a completely hermetic art. By the autumn of 1911 their analysis of form had led them to a point where all signs of the presence of the object itself had become difficult to trace. It became necessary to form a new link between painting and reality. Picasso had on several occasions demonstrated his love for his new companion, Eva (Marcelle Humbert), by introducing the letters of her name or the inscription *J'aime Eva* into his paintings, as a lover might carve initials in the bark of a tree. This addition, which might seem irrelevant, brought a new reference to reality into work otherwise verging on abstraction. Braque also had felt the same need. Having been trained by his father, a *peintre-décorateur*, in the techniques of painting *trompe l'œil* surfaces of marble and grained wood, he now introduced these into his work. Short-cutting Braque's painted imitations Picasso carried the idea further by taking a piece of oilcloth on which a pattern of chair-caning had been realistically reproduced, and sticking it to the canvas itself.

From this followed rapidly the use of newspaper, wallpaper or any other ready-made material which could serve the dual purpose of becoming part of the composition and adding its own reality to the picture. This addition of foreign materials applied to the canvas itself was a revolutionary step, breaking the tradition established since the Renaissance, when painters abandoned the medieval embellishments in gilt relief and insisted on a unity of material throughout the picture.

The new technique (*papier collé*) proved to be an important discovery. It enabled Picasso to work with great rapidity, sometimes pinning scraps of coloured or patterned paper on to his work and varying their positions as he desired. In the *Still Life with Chair Caning* (the work, produced in Paris, 1911–12, still belongs to the artist), the first painting in which Picasso used this new technique, the letters JOU, part of the word '*Journal*', are painted next to a glass which has all the characteristics of the earlier analytical devices of cubism. Both of them are situated close to the piece of oilcloth which simulates chair caning; thus they have various meanings and create varying degrees of deception, a device which has been described as a visual pun. The austerity of hermetic abstractions had given way to a light-hearted self criticism.

Another development was the return to colour, or rather coloured surfaces, which could, by their action on the eye, give a sensation of depth. The former system of gradations in tone which created crystalline facets tended to give way to simple flat or textured planes. Texture, it was found, could also be used to

differentiate between areas: it could put them on different planes and had the effect of a new method of perspective. The textures were in some cases created with sand, and in others simulated a 'pointillist' technique. By 1913 the monochromatic effects of early cubism had been abandoned; colour assumed a new role: it glowed from flat, evenly coloured and clearly defined areas and had no relationship to the Impressionist use of colour to create atmosphere.

A cubist painting was becoming an object in its own right; a tendency which brought Picasso to experiment in the creation of bas-relief constructions which were halfway between painting and sculpture.

During the early years of cubism, Picasso had devoted himself entirely to discoveries which led towards abstraction, but already in 1915 he began again to make drawings and some paintings in which he showed once more his extraordinary talent for conventional representation. Drawings of his friends, Max Jacob, Vollard, and Apollinaire, made during the war, have the assurance and purity of line of drawings by Ingres.

1917–24: *CUBISM AND CLASSICISM*

During the years of the war Picasso suffered not only from the dispersal of his friends but also from the death of Eva in the winter of 1915–16. Although he never ceased to paint and to develop the discoveries of cubism, his production during these years was less prolific. In the spring of 1917 he was persuaded by Jean Cocteau to go with him to Rome and design scenery and costumes for the ballet *Parade,* which was to be presented in Paris that summer. This expedition brought Picasso into contact with a new *milieu* and his visit to Italy revived his delight in classical forms and awakened a new interest in the *commedia dell'arte.* It was here that he met the young ballerina Olga Koklova, whom he married in the following year.

On his return to Paris his work showed frequent references to classical subjects, and the portraits of his beautiful young wife again show his consummate skill in representational painting. However, the achievements of cubism were never abandoned and he continued to develop this style with increasing strength. It culminated in two great canvases, variations on the same subject, *Three Masked Musicians,* painted in 1921 (Plate 24). The other version is in the Museum of Modern Art, New York. As a parallel to the cubist paintings, Picasso made many paintings of female figures, nude or with classical drapery. He emphasized the fullness of their forms, endowing them with a sense of fertility and motherhood. Whatever dimensions he used for the actual size of the canvas, these figures always suggest monumental proportions.

In 1921 Olga gave birth to a son and Picasso's work reflected at once his preoccupation with this event. Motherhood became a dominant theme in his painting in the neo-classical style.

With the renewed possibility of travelling during the summer months after the war, Picasso paid visits to the Mediterranean. During these years a subject which was repeated with many variations was a table laden with objects standing before an open window. Familiar objects such as the guitar, the bowl of fruit and wine bottles continued to be the chief elements in a series of still life paintings. After passing through a variety of moods, Picasso arrived at some of his major triumphs in the great canvases of 1924 and 1925. In these the techniques of cubism are used in a masterly way; the objects and their shadows interlock in great harmonious compositions, brilliant in colour and poetic invention.

1925–35: *THE ANATOMY OF DREAMS*

The strong influence of classicism on Picasso revealed itself not only in classical figures and compositions but also in the order and purity of form which he had imposed on the great cubist paintings, mostly still life, up to 1925. In this year,

however, a new torment that had begun to disturb his spirit revealed itself in a great canvas, *The Three Dancers*, 1925 (Plate 31). Here it is evident that the post-war hopes of a new Golden Age shared by so many had vanished, and yielded to a desperate ecstatic violence, expressive of frustrations and foreboding. This painting is the first to show violent distortions which have no link with the classical serenity of the preceding years. It heralds a new freedom of expression. During the following years the human form was to be torn apart, not with the careful dissection practised during the years of analytical cubism, but with a violence which has rarely been paralleled in the work of any artist. Picasso, however, not only decomposes and destroys, he invents new anatomies, new architectures and a new synthesis, incorporating the world of dreams with mundane reality (Plates 32, 33). By this means he is able to bring about a metamorphosis, more powerful and more profound than the simple *trompe l'œil* effects produced with oil paint on canvas. The most unorthodox, and even the meanest of materials can be given a new life and a new significance by him and it is in this feat that Picasso has continually shown his poetic strength. With materials as uninviting as nails, wire, paper and a floorcloth, he has created a picture which can have a violent emotional effect.

Picasso readily understood the desire of his surrealist friends to look for inspiration in the workings of the subconscious, and he allowed his paintings to be shown with theirs in group exhibitions. His conviction that painting should be conceptual rather than purely visual had always led him to value the friendship of poets, and the close link in surrealism between poetry and painting appealed to him strongly. His early association with André Breton and his long friendship with Paul Eluard gave birth to a period fertile in inventions.

Never in the work of Picasso do we find that the expression of emotion overwhelms formal considerations. Never does it become uncontrolled expressionism. His remodelling of the human form is based on cubist discoveries: for instance, the placing of two eyes surprisingly in a face seen in profile, a familiar characteristic from 1935 onwards, springs clearly not only from emotional promptings but also from the cubist intention to see that which is hidden but is known to exist (Plate 38). Nor has he ever abandoned his desire to interpret three-dimensional solidity of form. His methods of doing so vary, however, from the use of flat surfaces and tenuous lines to conventional shading to indicate volume. In the late 'twenties Picasso returned to bas-relief and sculpture, often inventing forms which were interchangeable in either medium. The head on the right in the painting *The Painter and his Model,* 1928 (New York, Sidney Janis) was also made up by Picasso as a painted metal construction, and this process of producing the effects he desired alternatively in either medium has increased in more recent work.

In 1932, with the space afforded by large out-buildings at his recently acquired Château de Boisgeloup, Picasso was able to produce a series of important sculptures. Some were made in iron with the technical aid of the sculptor Gonzalez; others were large plaster heads inspired by a new model, Marie-Thérèse Walter, who appears frequently in paintings of this period. In 1935, Marie-Thérèse bore Picasso a daughter, Maïa.

But sculpture was not the only art besides painting which occupied Picasso in the early 'thirties. It was during this period that with great vigour he produced some of his most remarkable graphic work, illustrating many books, such as the *Chef d'Œuvre Inconnu* of Balzac and Ovid's *Metamorphoses,* and later (in 1937) the *Histoire Naturelle* of Buffon, as well as books by his friends the poets Tzara, Eluard and others. In addition, Picasso himself found time to write many long poems, turbulent in form and violent in imagery. This prodigious activity has been characteristic of Picasso throughout his life, even during such years as these when he was undergoing the serious emotional stress which culminated in his separation from his wife.

An understanding of classical mythology combined with a hereditary passion for the bullfight had led Picasso to meditate on the strange personality of the Minotaur. In a series of etchings known as *The Sculptor's Studio*, 1933, and in some remarkable drawings of the same period, this equivocal beast is seen, sometimes amorous, sometimes ferocious and sometimes blind, penetrating into human society. The subconscious power of the myth and Picasso's longstanding love of allegory served him as a basis for a great new painting which he was to produce in 1937. The mural which Picasso produced for the Spanish Pavilion in the Paris Exhibition that year was inspired by his anger at the destruction of the Basque capital Guernica by the forces of General Franco. This great painting, now on loan to the Museum of Modern Art, New York, is a composition which expresses magnificently the anguish of a great human disaster and owes its power to Picasso's development through cubism to a new visual language.

Although *Guernica* was painted with extraordinary speed, Picasso found time to preface the final picture with many studies, such as the *Horse's Head,* 2 May 1937 (New York, Museum of Modern Art, on loan from the artist), and the *Woman Weeping*, June 1937 (Paris, Mme Dora Maar), as well as numerous drawings of great emotional power. Its echoes continued into the autumn with paintings such as *Woman and Dead Child*, September 1937 and the *Woman Weeping*, 26 October 1937 (see cover illustration). These paintings are concentrations of the anguish which pervades the great composition.

In all Picasso's work of this period there is a foreboding which sometimes rises to intensity in paintings such as *Cat Devouring a Bird*, 1939 (Plate 39), and at other times reaches a raucous note of grim humour. In the great canvas, *Night Fishing at Antibes* (Museum of Modern Art, New York), the atmosphere of war which was to break out a few days later exists already in the sinister grimaces of the fishermen and the feckless grins of the girls standing beside their bicycles. The paintings that follow are deeply marked with Picasso's emotions of anguish bordering on despair, though at times his love for Dora Maar, who had shared his life since 1936, is evident in the brilliant drawings and portraits of her (Plate 41), and there are signs of a similar tenderness in portraits such as those of his daughter Maïa, and of Nusch, wife of Paul Eluard.

As the war continued, and the situation around him became catastrophic, Picasso's reactions became increasingly intense.

There are pictures such as *Woman Dressing her Hair*, 1940 (New York, Mrs Louise R. Smith) which seem to echo a violent resentment at the horror and stupidity of war. Apart from a few still-life paintings of great charm, the work of Picasso is full of angry dark thoughts. His studies of the human head go through violent distortions, sometimes combining the features of Dora Maar and the angular snout of his Afghan hound Kasbek, two heads in one revealing two contradictory moods.

Though materials were scarce, Picasso's wartime output was prodigious in painting and also in sculpture. It was in 1943 that he modelled, among others, a major piece, the *Man with the Sheep,* afterwards cast in bronze, in spite of the ban on using metal for sculpture.

During the comfortless winter of 1941 Picasso surprised his friends by writing in four days a short drama, entitled *Desire Caught by the Tail*. In this it can be seen that his sense of the ridiculous and his understanding of the pathetic insecurity and weakness of the human condition never left him. The still-life paintings that he produced at this time are permeated with a sense of death whose emblem appears frequently in company with a shrouded lamp or withered plants. These paintings culminated at the end of the war in another great painting, *The Charnel House* (New York, Chrysler Collection), painted in the summer of 1945, which is the epitome of Picasso's feelings concerning the horror of war and its universal consequences.

Towards the end of the war, in a happier mood, Picasso painted several landscapes from the *quais* near his studio, of the city in which he had spent these years of misery with his friends.

1946–54: *ANTIBES AND VALLAURIS*

As soon as the exhilaration of liberation and the return of old friends from abroad had subsided, Picasso made his way again to the Mediterranean. In the previous months spent in Paris he had worked intensively at lithographs, many of which were scenes of bullfights and still-life subjects. Soon after his arrival in the south of France he was offered the vast halls of the Palais Grimaldi in Antibes as a studio, and the subject matter of his work changed abruptly. Again legendary figures predominated in his thoughts. The idyllic charm of nymphs, fauns, centaurs and satyrs, dancing and regaling themselves in Arcadian scenes, appeared in paintings and lithographs, and among them emerged a new face, radiant as the sun and delicate as a flower, that of Françoise Gilot, who had accompanied him. The work of this period is collected together in the museum at Antibes, forming a testimony to months of newly-won tranquillity.

In 1947, the year in which Françoise gave birth to their son Claude, Picasso became attracted by the possibilities offered by the potteries of Vallauris, and a year later he moved there with his new family. This began a period of great creative production in ceramics, an art which he treated in a similar way to polychrome sculpture. At the same time he continued to paint with great vigour. Portraits of Françoise, his son Claude and his daughter Paloma, born in 1949, are usually brilliant in colour and decorated with vigorous flourishes and arabesques. The paintings of his children at play, reading, or lying in bed asleep show tender observation of their behaviour. Unlike the paintings of the Blue Period, they are devoid of all sentimentality and reveal the complex joys and passions of childhood. The Mediterranean landscape around him was also an enchantment to Picasso both by night and by day, and remained always closely associated with his proverbial love of the sea.

The presence of Picasso brought new prosperity to Vallauris and was greatly appreciated by the inhabitants. The life-size bronze *Man with the Sheep* was set up in the main square, and Picasso was invited to decorate a small and beautiful medieval chapel which had fallen into disuse. To cover the vault of its nave, he painted in 1952 two large panels displaying allegories of war on one side and of peace on the other.

There is an abundance of variety in the styles used by Picasso during these years, varying from the almost abstract composition of the *Goat's Skull, Bottle and Candle* (Plate 43) to the fantasy and playfulness of the *Sport of Pages*, 1951 (collection of the artist). This latter corresponds more closely in style to the great paintings of *War* and *Peace*, although in these the symbolic figures are treated with less detail and the overall appearance is one of grave simplicity.

1955–61: *CANNES AND VAUVENARGUES*

On 13 December 1954 Picasso began work on a series of fifteen variations on Delacroix's painting *The Women of Algiers* (Plate 45), which he finished on 15 February 1955. This was not the first time that he had taken the theme of a painting which he admired and without any intention of copying the original, used it as a basis for variations on the composition in his own terms. Previous examples came from very varied sources: Le Nain in 1917, Renoir in 1919, Poussin in 1944, Cranach in 1947–9 (Mourlot, *Picasso Lithographe*, Paris, vol.II, 1950, 109 and 109 bis), Courbet and El Greco in 1950 (Plate 44) and more recently Velazquez, *Las Meninas* (The Ladies in Waiting). There are two versions of the Delacroix *Les Femmes d'Alger*: one in the Louvre and the other in the Musée Fabre at Montpellier, but Picasso states that he had not seen either of them

for many years. His visual memory allowed him, however, to work on the variations even without the aid of a reproduction. In quick succession he painted a number of variations, some in monochrome and others with brilliant colour, interpreting the composition and the anatomy of the women with his usual boldness. The same trend, beginning with more representational studies and arriving at nearly abstract conceptions in the latest work, can be found in the series of *Las Meninas*, painted three years later.

After his rupture with Françoise Gilot in 1953, Picasso found a new and devoted companion in Jacqueline Roque. His love for her is evident in portraits painted in June 1954. With her he installed himself in the villa *La Californie*, overlooking the sea near Cannes. Although the architecture of this house is in no way pleasing it afforded him ample space for his work and its interior, often with Jacqueline seated among his canvases and sculpture, became the theme for many important paintings. The diversity of his activities, with ample working space at Cannes and Vallauris still within reach, became even greater; painting, sculpture, ceramics, engraving and lithography occupied the greater part of his time. In addition, in the summer of 1953 he became the sole star performer in a film produced by Georges Clouzot entitled *Le Mystère Picasso*.

In the paintings of these years echoes of the many experiences through which he had lived can be found, as well as the perennial, underlying influence of cubism. His mastery of so many styles enabled him to work with great assurance, freedom and speed. Painting became more than ever linked with sculpture. Bronzes often inspired by the metamorphosis he could create by the assemblage of surprisingly dissimilar objects came to life in the same playful way in which his early 'collages' had been produced. In many cases the metal was painted, producing a unity between painting and sculpture. Intuitively he was continuously inventing unconventional techniques to produce new effects. Whatever means tempted him would be given a trial, such as the use of feathers from his pigeons picked up from the floor instead of brushes, an idea which produced *L'Arlésienne* of 1958.

In the autumn of 1958 Picasso embarked on a period of exceptional concentration, shutting himself off from his friends for more than two months. During this time he painted a series of variations on *Las Meninas* of Velazquez, a painting that had fascinated Picasso when he first visited Madrid with his father at the age of fourteen. Working rapidly on a great number of canvases of all sizes he vigorously transformed Velazquez' handling of this strangely ambiguous version of the old theme, the artist and his model. He respected the principal elements in this dramatic composition, the lighting, the spacing of the figures, their gestures, and even the texture of their dresses, but he became ruthless in the transformations he brought about. At the same time, as a foil to Velazquez' sombre version of the interior of the Spanish court, inherited from the past, he also became preoccupied with a scene that presented itself daily, framed by the studio window from which his pigeons launched themselves into the radiant atmosphere of the Mediterranean. The complete series was presented by Picasso five years later to the new museum dedicated to him in Barcelona.

Other major works soon began to occupy Picasso's attention, in particular, the great mural which he painted in Cannes for the new Unesco building in Paris. The first photographs of the painting, published in the press, met with severe criticism and when it was shown in the playground of a school in Vallauris, several critics expressed their disappointment. Once the panels on which it had been painted were set in place in Paris it became apparent, however, that Picasso had compensated brilliantly for the difficulties imposed by the architecture of the hall, although he had been given no more than a small model to work from. It is impossible to see the whole composition except from very close quarters, but the theme, with allegorical overtones that suggested *The Fall of Icarus* as an appropriate title, unfolds itself dramatically to the spectator as he moves towards it and as the whole painting gradually comes into view. The subtle way in which this

gigantic mural enhances its surroundings and works with them without Picasso having been able to see it in place is a further proof of his intuitive understanding of visual problems.

The increased popularity of bullfighting in France since the war and its inevitable association with Spain reawakened Picasso's enthusiasm for the arena. His 75th birthday was celebrated at Vallauris by a mock bullfight and in the same year he completed a splendid series of drawings and engravings made after his visits to the more traditional corridas that took place in the Roman arenas of Provence. On his return from one of these events in Arles, in the autumn of 1958, he stopped at the Château de Vauvenargues which was then for sale and a few days later he became its owner. This ancient château is situated at the foot of the Mont Ste. Victoire, made famous by the landscapes of Cézanne. For a few years, he escaped at times during the summer to its seclusion and produced paintings in which the colours of water, meadows, dark pines and the brilliant whiteness of limestone rocks form the background for the gaily dressed figures. It was in this atmosphere that Picasso embarked on another series of variations inspired this time by Manet's *Déjeuner sur l'Herbe* (Paris, Jeu de Paume), introducing into them the deep shadows and brilliant verdure that surrounded him at Vauvenargues, and obtaining atmospheric effects that would have been the envy of the Impressionists.

It was not long before Picasso found that the comfort of a large modernized Provençal house near Mougins, which has the appropriate name of 'Mas Notre Dame de Vie', suited him better than the wild beauty of Vauvenargues or the Villa La Californie, which was rapidly being encroached on by tall blocks of apartments. Moving there in 1961, he enlarged it with new studios and lived there in seclusion, rarely moving out into the world. He surrounded himself with all the facilities necessary for his work which occupies him daily and often late into the night. In addition, his needs are continuously and zealously satisfied by his wife Jacqueline, whom he married in 1961.

NOTRE DAME DE VIE

The change of dwelling did not interrupt the main flow of Picasso's work. The *Déjeuner sur l'Herbe* series led to new interpretations of that recurring theme, the 'Artist and his Model' (Plate 48). Former discoveries blossomed forth again with great variety and unprecedented freedom in the manipulation of paint and reconstructions of the human body. The theme allowed him to express with endless variety his insatiable interest in the female form seen often as an integral part of the landscape. It was accompanied in 1963 by canvases varying in size from two metres high to small compositions of the subject *The Rape of the Sabines,* which introduced again an element of violence without the anguish of *Guernica.*

As usual, intensive periods of painting were interspersed with other methods of expression. With his usual ingenuity Picasso revolutionized the somewhat banal technique of the lino-cut and produced by new methods a great quantity of large prints in colour, the subject varying from still lifes of fruit at night under the blaze of a naked electric lamp to idyllic scenes of fauns, bulls and centaurs. Also there were smaller, imaginary lino-cut portraits of elegant courtiers and ladies of the sixteenth century. The grandee had frequently appeared in the past with sword, wig, cloak and ruff, often as a mockery of pompous Spanish traditions, but at other times he is more closely related to Rembrandt and has a more bucolic appearance. It is this character who seems to form a link between the aristocracy of the past, with its mixture of refinement, arrogance or egotistical stupidity, and Picasso's intimate feelings about himself—now that his genius is so universally acclaimed—feelings haunted by that inner doubt about his own achievements that still follows him as his shadow.

This was borne out in the great exhibition at Avignon in the Palais des Papes when 165 canvases and 46 drawings which were all produced in one year, 1969,

were shown. The hidalgo in full regalia including pipe and broad brimmed hat dominated, sometimes having the austerity of Zurbarán's monks and elsewhere the appearance of the most debauched courtier of Frans Hals.

During the early years of the 1960s, Picasso devoted much of his time to sculpture. The process he had developed in his early cubist period of making figures out of bent sheets of cardboard and which he completed with paint, was used again to build maquettes for sculptures which under his supervision were consolidated in sheet iron. Many of these are portraits of Jacqueline, in which empty space comes to life between the folded surfaces of the painted metal. As a direct development of this technique there emerged the monumental sculpture in iron in the Civic Center of Chicago, and others (in New York, Marseilles, and many other cities) in sand-blasted concrete, a process which has been of great value in reproducing in monumental form some of the sheet iron sculptures and in incising in concrete walls drawings made by Picasso for this purpose. In the majority of these works there is remarkable cohesion between sculpture, drawing and painting, and the scale in which the major figures have been executed places them among the greatest monuments of our time.

Picasso has also devoted much of his energy to engravings, varying greatly in size. In the summer of 1968 he produced with great speed a series of 347 engravings in which his imagination produced a fabulous richness of subject matter employing old themes such as the circus, bacchanalian orgies, the artist and his model, and the ubiquitous grandee, all with startling freshness. The unhesitating manner with which the figures are drawn and the invention of new techniques would make this series alone a triumph for a mature artist half Picasso's age. It is in particular the firmness of his line and the inexhaustible fertility of his imagination which still make Picasso at the age of 90 the most youthful artist alive.

The fame of Picasso is now undisputed and will long be remembered. If he wished to take advantage of the wealth he has created, and continues to create, by his own labour he might rank materially as the richest man alive, but this could not match the richness of the vital ideas and sheer enjoyment that he has distributed so abundantly and which is of a quality that can justify his saying: "Each picture is a phial filled with my blood. That is what has gone into it." As he becomes more isolated in the solitude of old age he becomes even more involved in his art. He demands no more than to live with simplicity, surrounded by the love and attention of his wife, with his work as an uninterrupted drama which will never reach its final conclusion and in which wonder and doubt stimulate his proverbial youthfulness.

List of plates

1. *Self-portrait*. 1901. Canvas: 74 × 60 cm. Sold Christie's London, 30 June, 1970.

2. *Pedro Mañach*. 1901. Canvas: 105 × 71 cm. Washington, D.C., National Gallery of Art (Chester Dale Collection).

3. *Child holding a Dove*. 1901. Canvas: 73 × 54 cm. London, Dowager Lady Aberconway.

4. *The Old Guitarist*. 1903. Panel: 122 × 83 cm. Chicago, Art Institute.

5. *Boy with a Pipe*. 1905. Canvas: 100 × 81 cm. New York, John Hay Whitney Collection.

6. *The Tragedy*. 1903. Panel: 105 × 69 cm. Washington, D.C., National Gallery of Art (Chester Dale Collection).

7. *La Vie*. 1903. Canvas: 197 × 129 cm. Cleveland, Museum of Art (Gift of Hanna Fund, 1945).

8. Detail from *La Vie*. (Plate 7).

9. *Woman in a Chemise*. About 1905. Canvas: 73 × 60 cm. London, Tate Gallery.

10. *Les Trois Hollandaises*. 1905. Canvas. Paris, Musée d'Art Moderne.

11. *Family of Saltimbanques*. 1905. Canvas: 213 × 230 cm. Washington, D.C., National Gallery of Art (Chester Dale Collection).

12. *Juggler with Still life*. 1905. Gouache on cardboard: 100 × 70 cm. Washington, D.C., National Gallery of Art (Chester Dale Collection).

13. *Nude Girl against a red background*. 1906. Canvas. Paris, Private Collection.

14. *Self-portrait*. 1906. Canvas: 90 × 70 cm. Philadelphia, Museum of Art (Gallatin Collection).

15. *Gertrude Stein*. 1906. Canvas: 100 × 81 cm. New York, Metropolitan Museum of Art (Bequest of Gertrude Stein, 1946).

16. *Les Demoiselles d'Avignon*. 1907. Canvas: 244 × 233 cm. New York, Museum of Modern Art.

17. *Three Women*. 1908. Canvas: 200 × 179 cm. Leningrad, Hermitage Museum.

18. *Seated Nude*. 1909–10. Canvas: 92 × 73 cm. London, Tate Gallery.

19. *Nude*. 1910. Canvas: 98 × 76 cm. Buffalo, New York, Albright-Knox Art Gallery.

20. *Daniel-Henry Kahnweiler*. 1910. Canvas: 101 × 73 cm. Chicago, Art Institute (Gift of Mrs. Gilbert W. Chapman).

21. *Man with a Pipe*. 1911. Canvas: 91 × 72 cm. Fort Worth, Texas, The Kimbell Art Foundation.

22. *Vive La France*. 1914. Canvas: 52 × 64 cm. Chicago, Illinois, Mr. and Mrs. Leigh B. Block.

23. *Fruit-dish, Bottle and Guitar*. 1914. Canvas: 92 × 73 cm. Private Collection.

24. *Three Masked Musicians*. 1921. Canvas: 203 × 188 cm. Philadelphia, Museum of Art (Gallatin Collection).

25. *Harlequin*. 1918. Canvas: 147 × 67 cm. St. Louis, Missouri, Joseph Pulitzer.

26. *The Lovers*. 1923. Canvas: 130 × 97 cm. Washington, D.C., National Gallery of Art (Chester Dale Collection).

27. *Madame Picasso*. 1923. Canvas: 101 × 82 cm. Washington, D.C., National Gallery of Art (Chester Dale Collection).

28. *Woman in a Blue Hat*. 1923. Pastel. London, Tate Gallery (on loan from the James Foundation).

29. *Head of Paul*. 1923. Canvas. Collection of the Artist.

30. *The Rape*. 1920. Tempera on panel: 24 × 33 cm. New York, Museum of Modern Art (The Philip L. Goodwin Collection).

31. *The Three Dancers*. 1925. Canvas: 215 × 143 cm. London, Tate Gallery.

32. *Figures by the Sea*. 1931. Canvas: Private Collection.

33. *Seated Bather*. 1930. Canvas: 164 × 130 cm. New York, Museum of Modern Art.

34. *The Sculptor*. 1931. Canvas. Private Collection.

35. *Nude Woman in a Red Armchair*. 1932. Canvas: 130 × 97 cm. London, Tate Gallery.

36. *Head of a Sleeping Woman*. 1932. Canvas: 53 × 44 cm. London, Tate Gallery (on loan from the James Foundation).

37. *Woman asleep in an Armchair (Le Rêve)*. 1932. Canvas. New York, Private Collection.

38. *La Muse*. 1935. Canvas: 130 × 165 cm. Paris, Musée d'Art Moderne.

39. *Cat devouring a Bird*. 1939. Canvas: 97 × 129 cm. New York, Private Collection.

40. *Woman in a Fish Hat*. 1942. Canvas. Amsterdam, Stedelijk Museum.

41. *Dora Maar*. 1938. Paper. London, Tate Gallery.

42. *La Casserole émaillée*. 1945. Canvas. Paris, Musée d'Art Moderne.

43. *Goat's Skull, Bottle and Candle*. 1952. Canvas: 89 × 116 cm. London, Tate Gallery.

44. *Les Demoiselles des bords de la Seine* (free variation after Courbet). 1950. Plywood: 100 × 202 cm. Basle, Kunstmuseum.

45. *Les Femmes d'Alger* (free variation after Delacroix). 1955. Canvas. Collection of the Artist.

46a. Ceramic Pot.

46b. Ceramic Plate, decorated with a design showing a man fighting a centaur.

47a. Ceramic Plate, decorated with a goat's head.

47b. *Spring*. 1956. Canvas. Paris, Private Collection.

48. *Painter and Model*. 1963. Canvas. Paris, Private Collection.

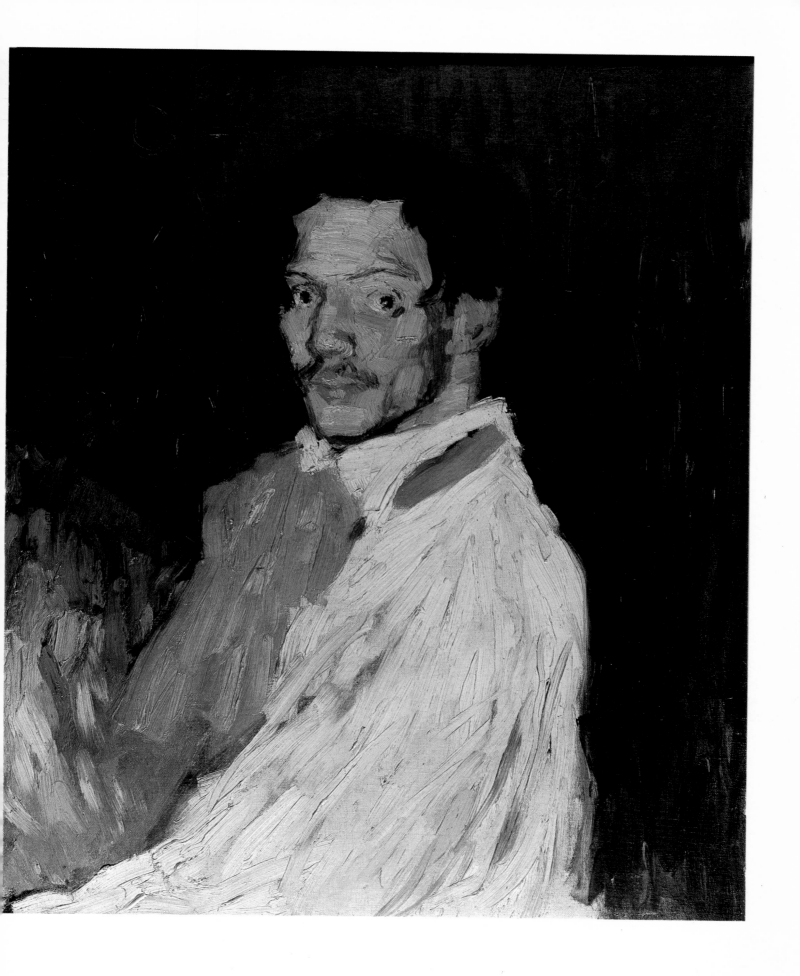

SELF-PORTRAIT. 1901. Sold Christie's, London, 30 June, 1970

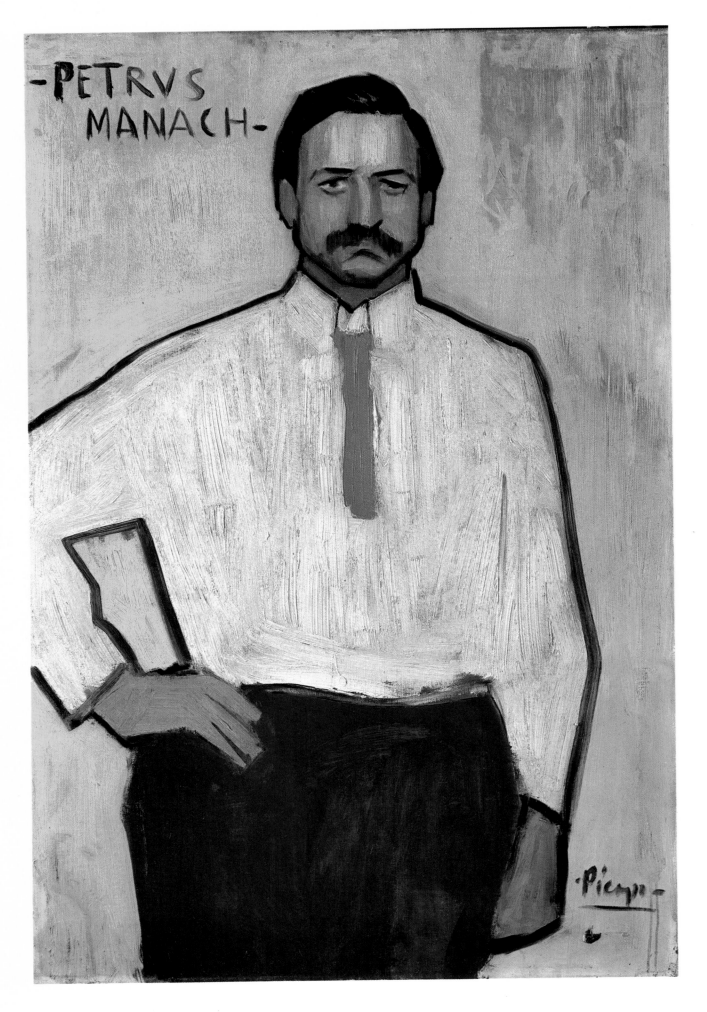

2. *PEDRO MAÑACH*. 1901. Washington, D.C., National Gallery of Art (Chester Dale Collection)

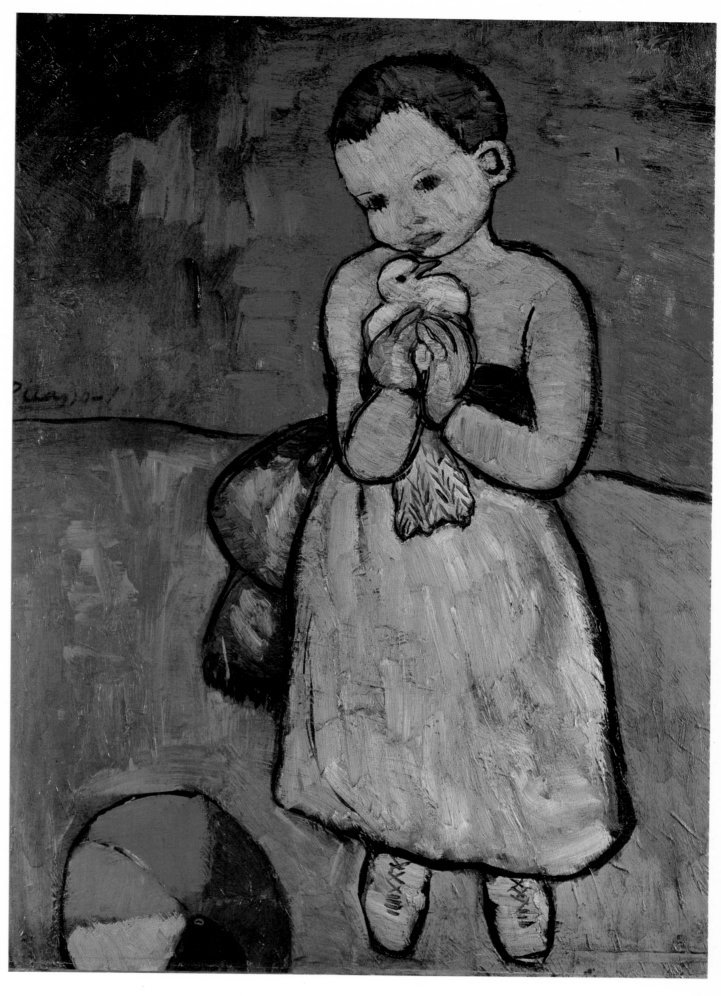

3. *CHILD HOLDING A DOVE*. 1901. London, Dowager Lady Aberconway

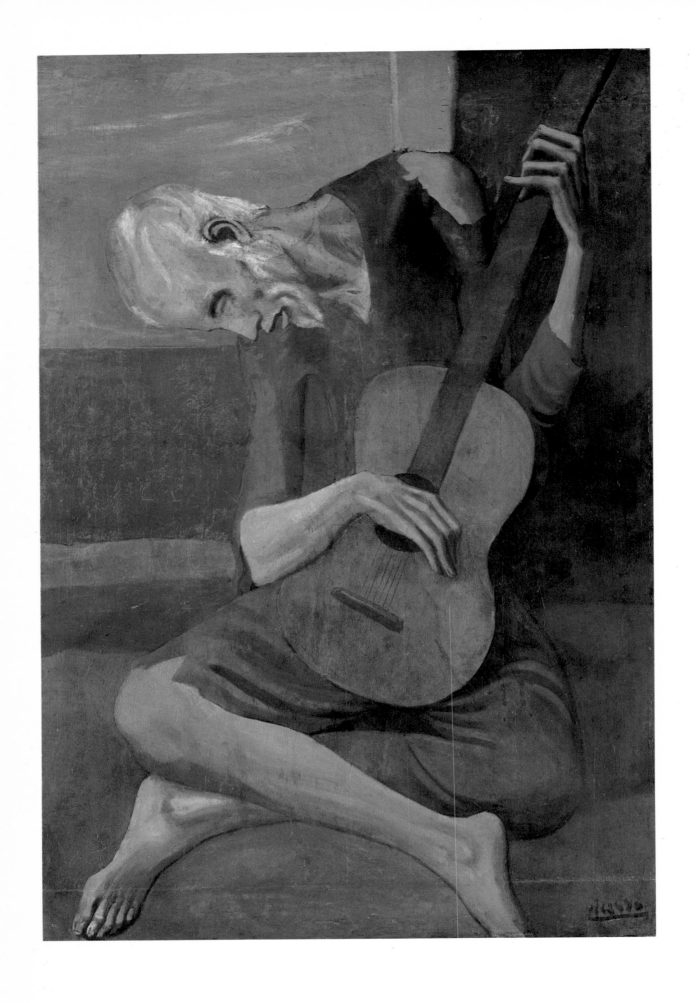

4. *THE OLD GUITARIST*. 1903. Chicago, Art Institute

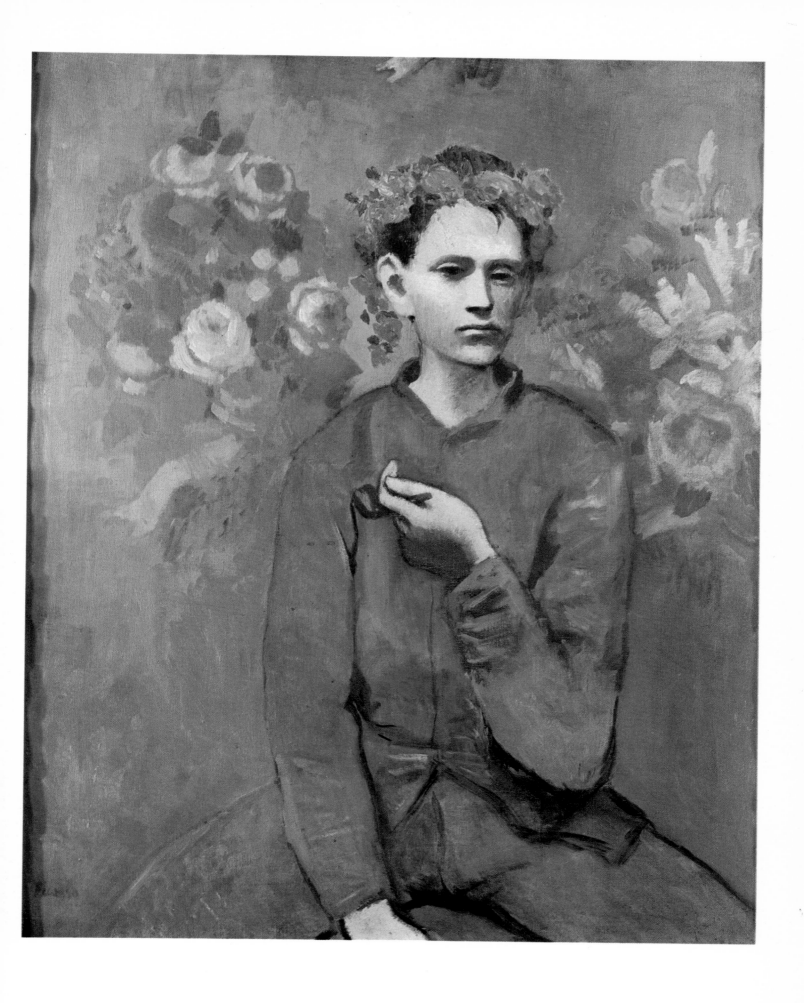

5. *BOY WITH A PIPE*. 1905. New York, John Hay Whitney Collection

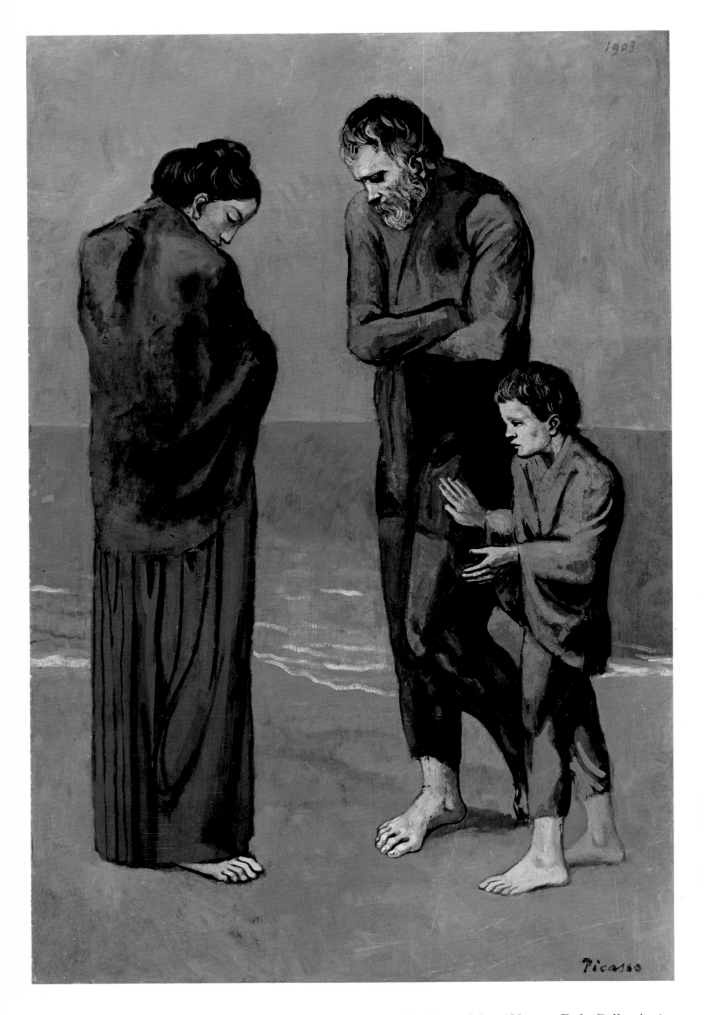

6. *THE TRAGEDY*. 1903. Washington, D.C., National Gallery of Art (Chester Dale Collection)

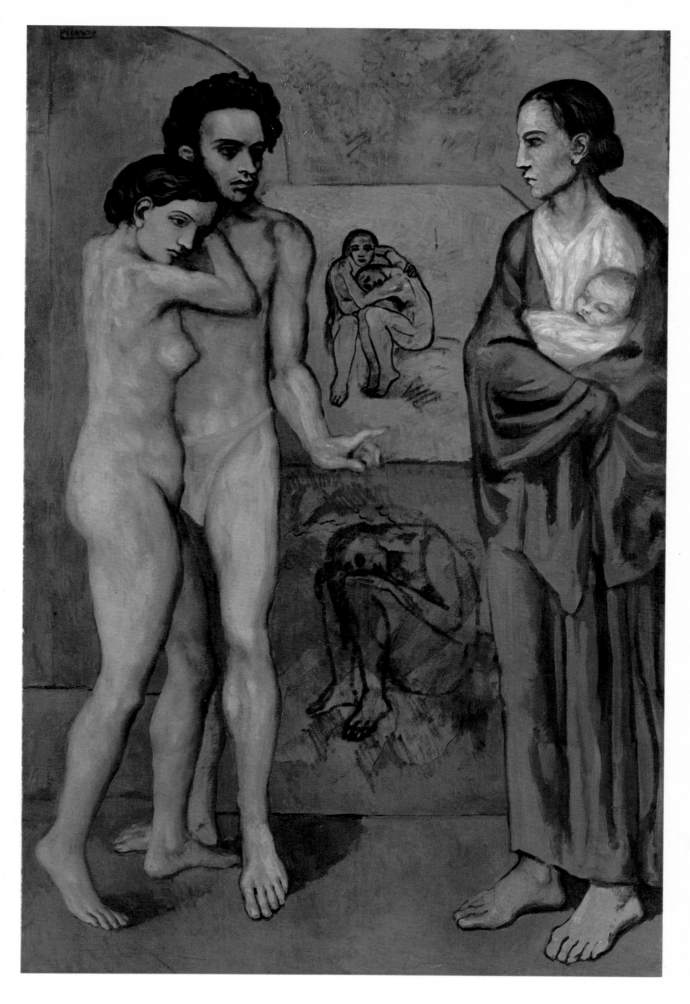

7. *LA VIE*. 1903. Cleveland, Museum of Art (Gift of Hanna Fund, 1945)

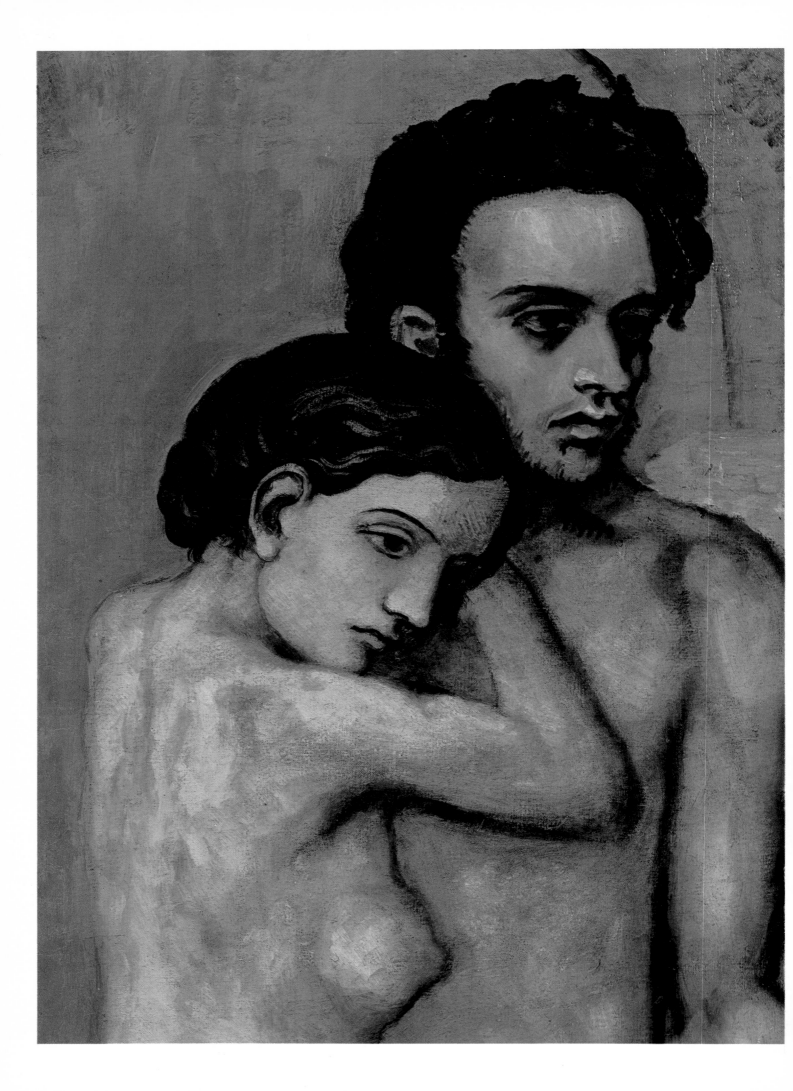

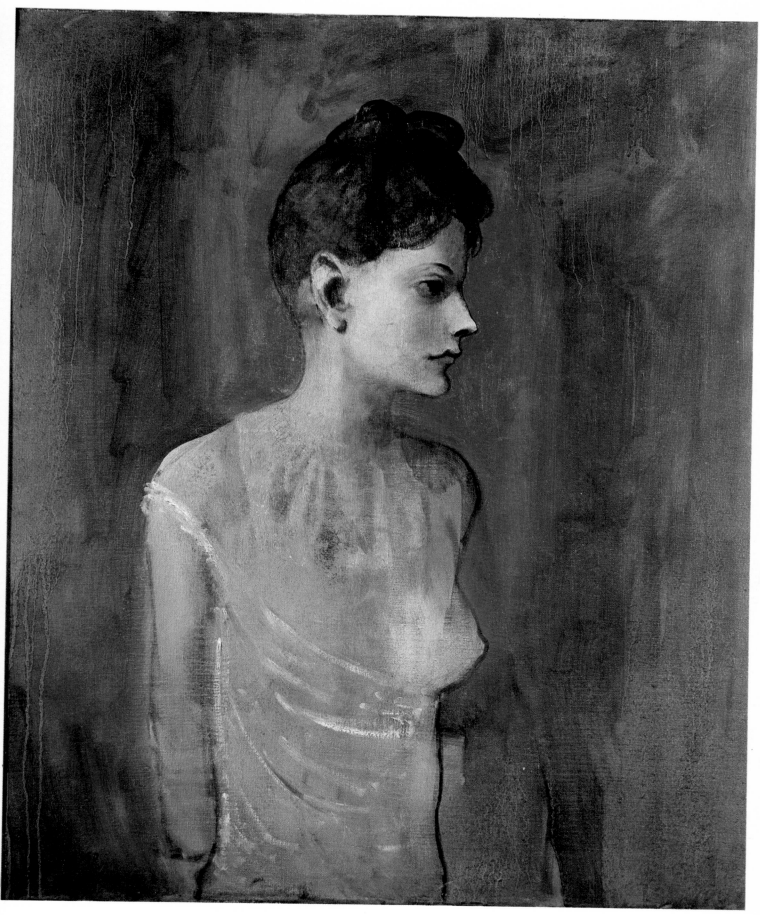

9. *WOMAN IN A CHEMISE.* About 1905. London, Tate Gallery

8. Detail from *LA VIE* (Plate 7)

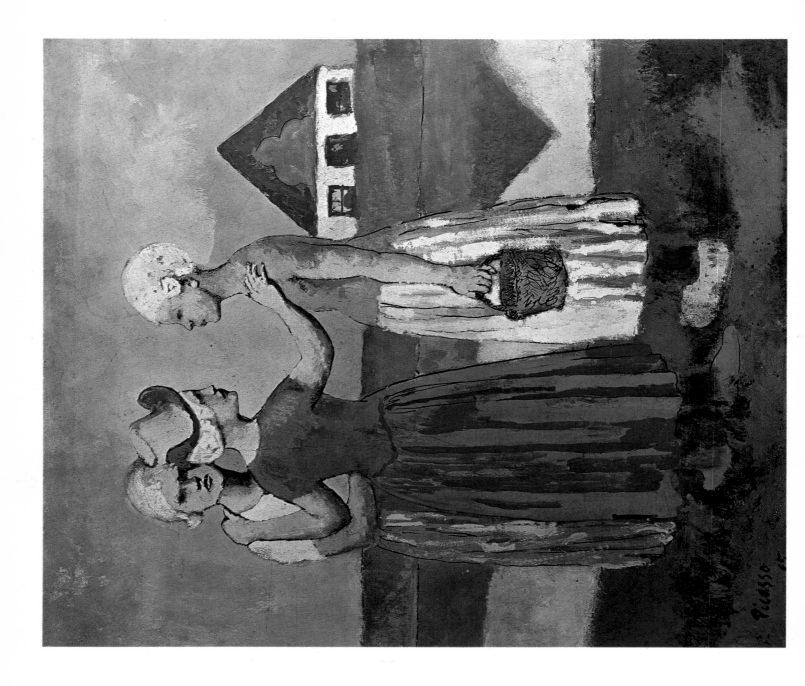

10. *LES TROIS HOLLANDAISES.*
1905. Paris, Musée d'Art Moderne

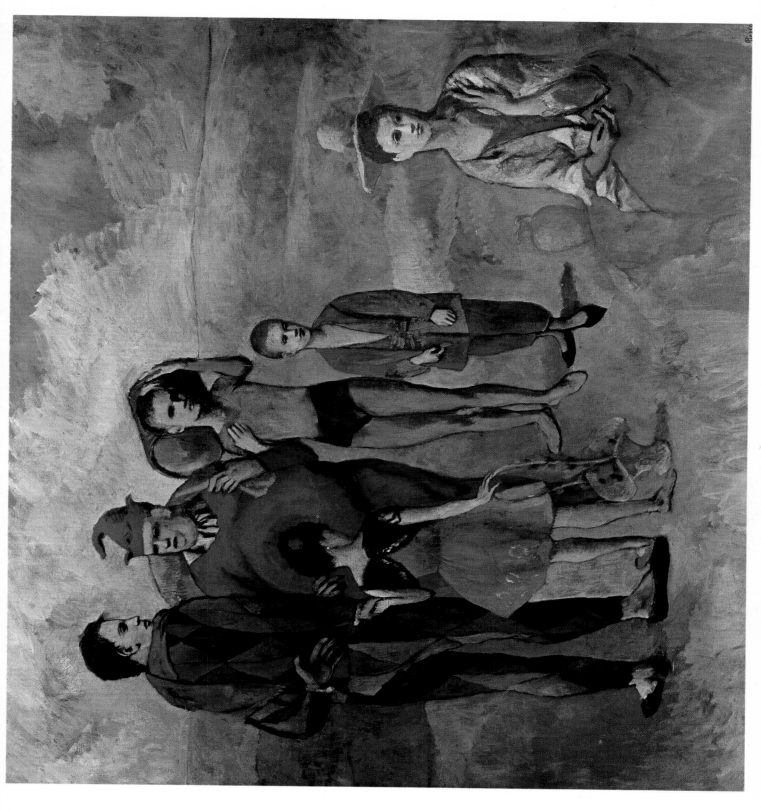

11. *FAMILY OF
SALTIM-
BANQUES.*
1905.
Washington,
D.C., National
Gallery of Art
(Chester Dale
Collection)

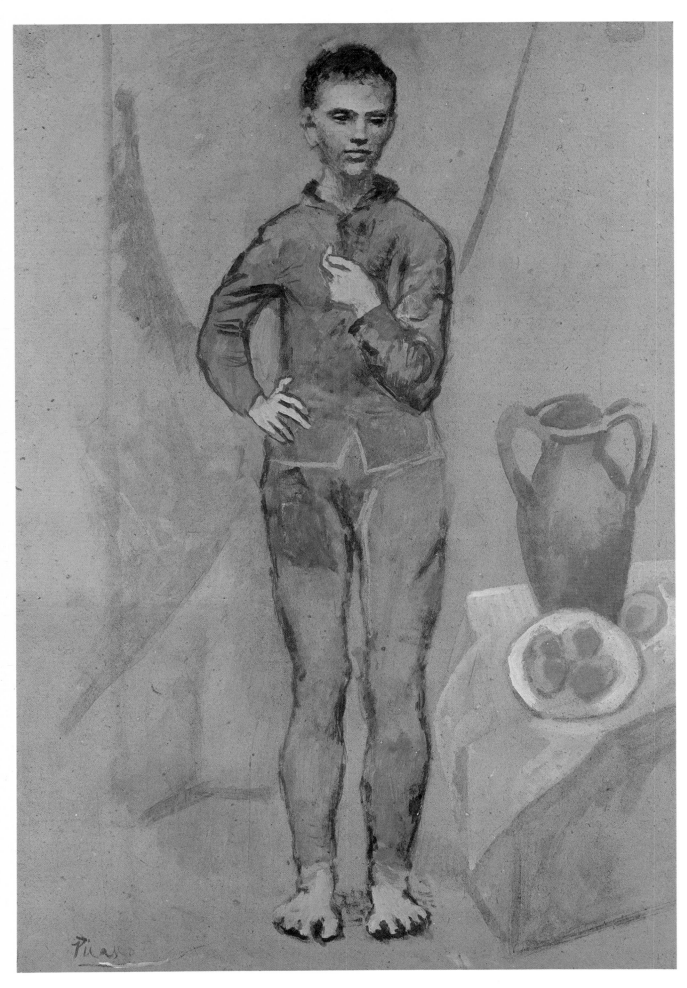

12. *JUGGLER WITH STILL LIFE*. 1905.
 Washington, D.C., National Gallery of Art (Chester Dale Collection)

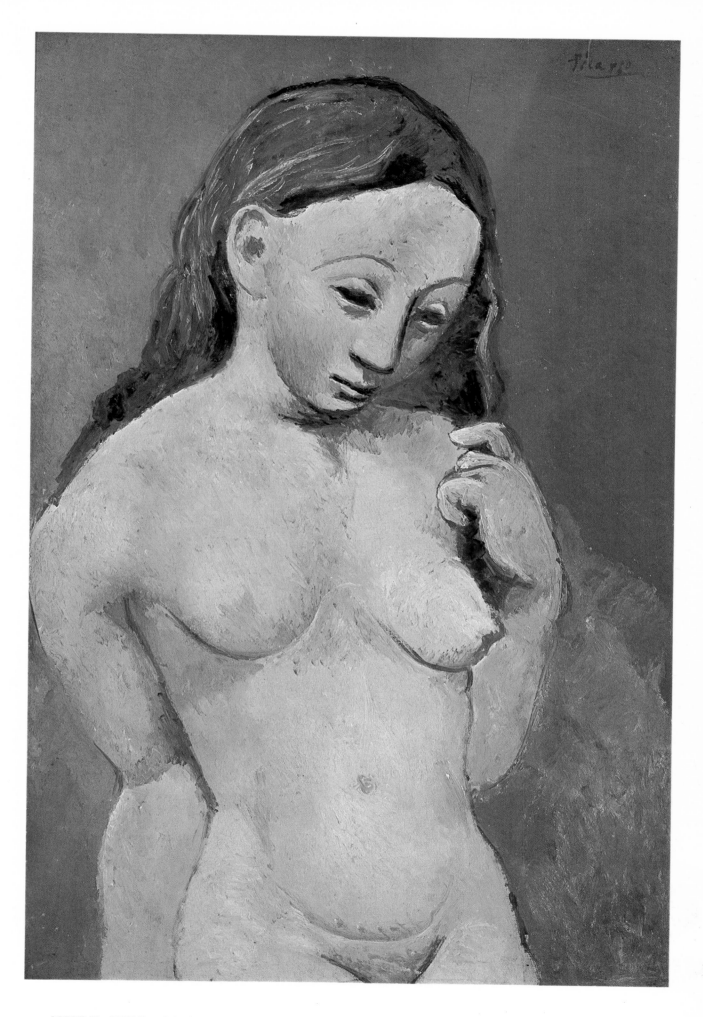

13. *NUDE GIRL AGAINST A RED BACKGROUND*. 1906. Paris, Private Collection

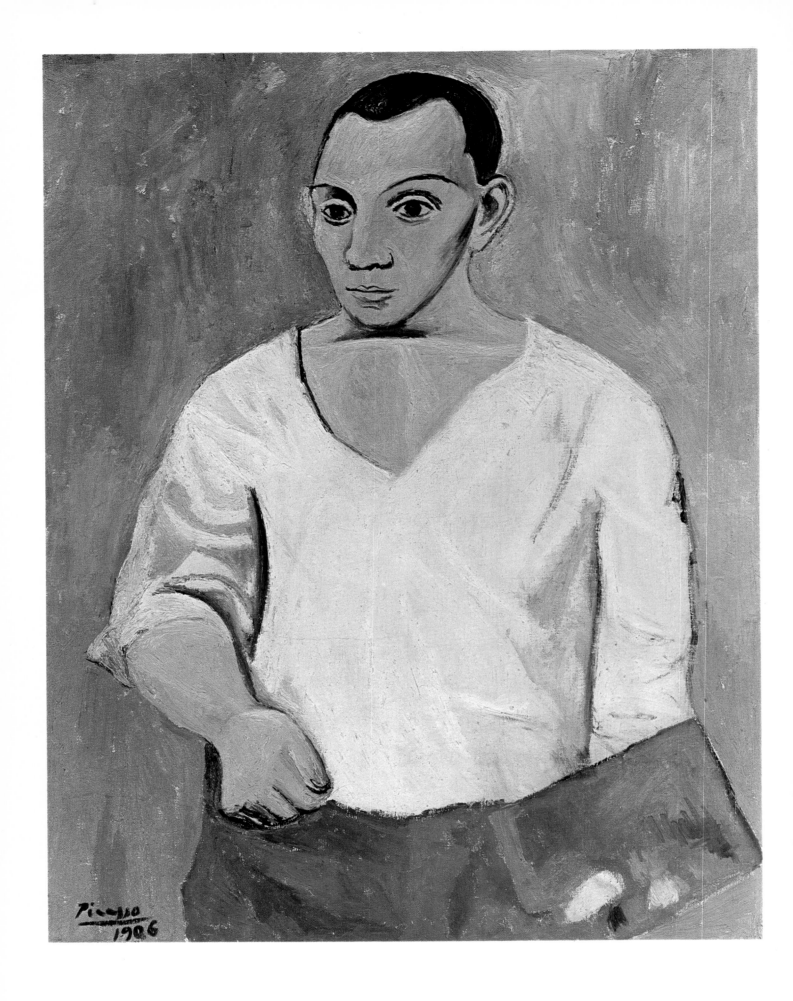

14. *SELF-PORTRAIT*. 1906. Philadelphia, Museum of Art (Gallatin Collection)

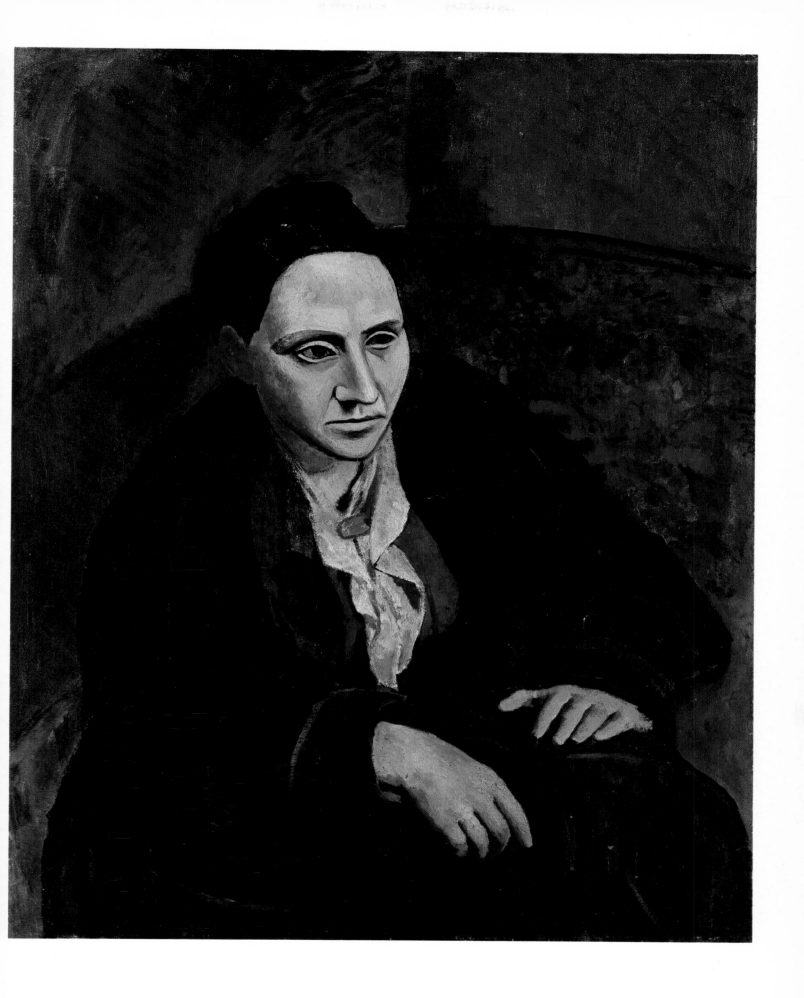

15. *GERTRUDE STEIN*. 1906. New York, Metropolitan Museum of Art (Bequest of Gertrude Stein, 1946)

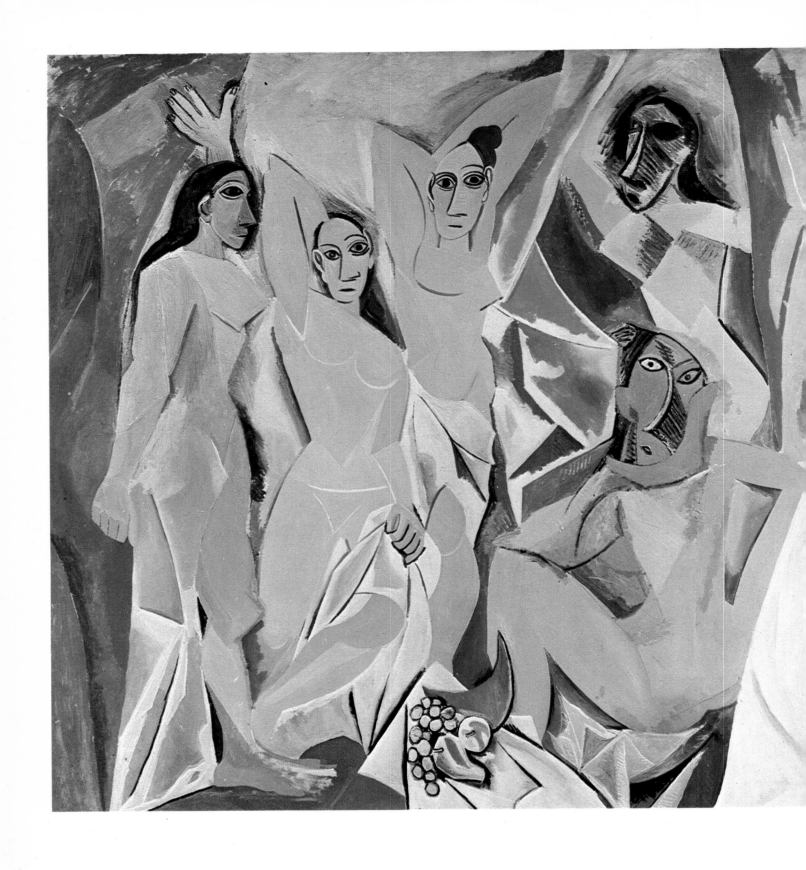

16. *LES DEMOISELLES D'AVIGNON.* 1907. New York, Museum of Modern Art

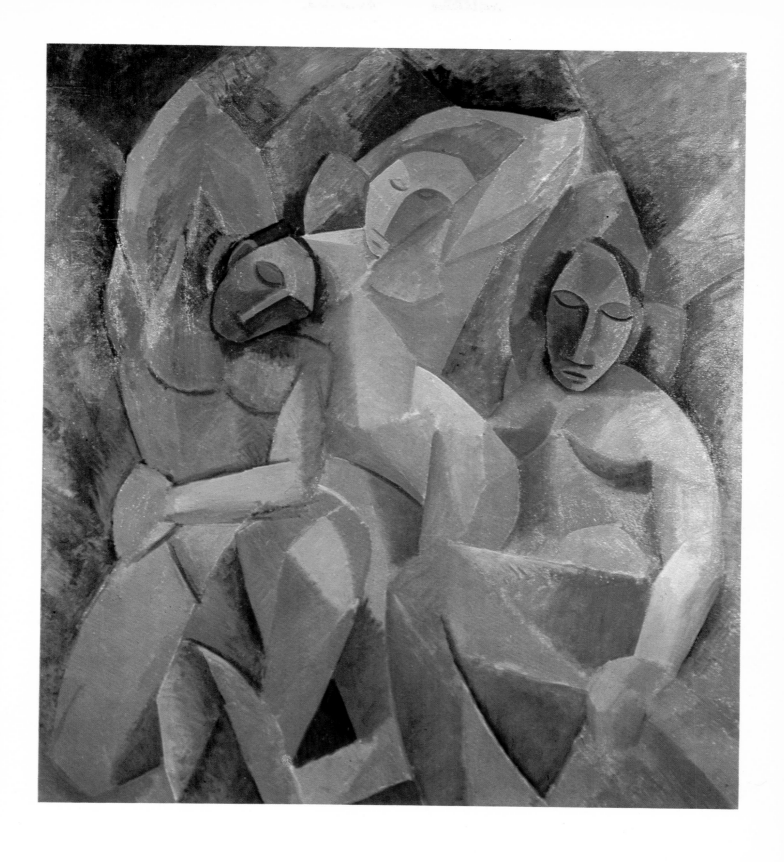

17. *THREE WOMEN*. 1908. Leningrad, Hermitage Museum

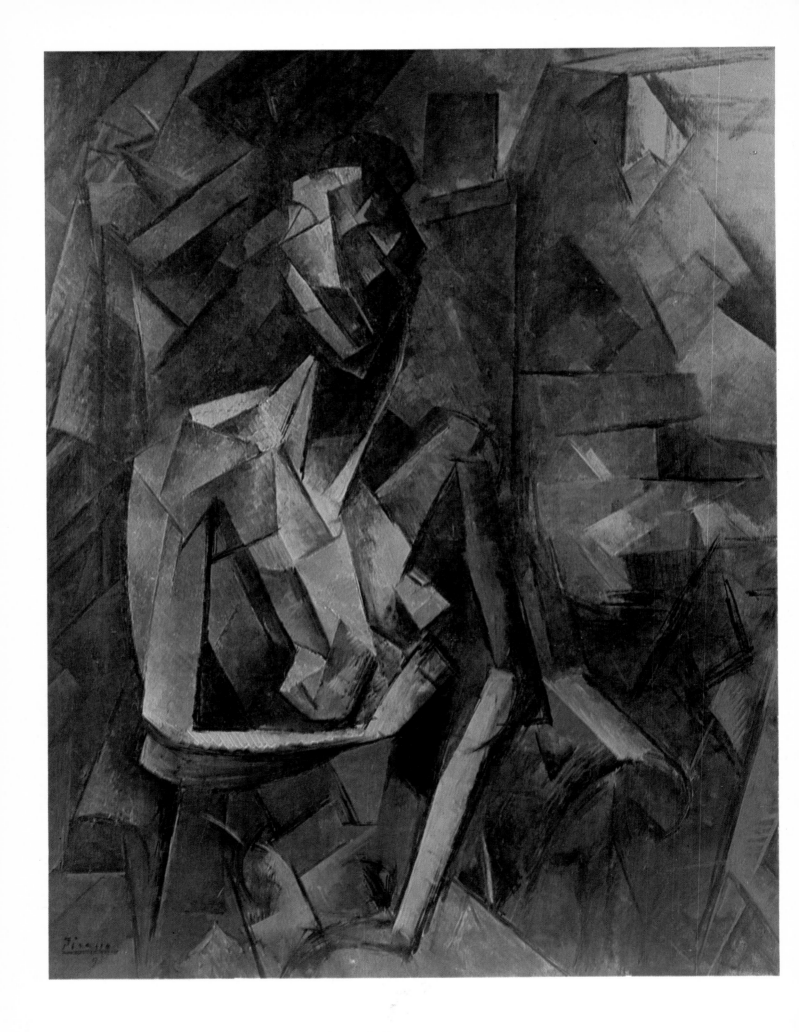

18. *SEATED NUDE*. 1909–10. London, Tate Gallery

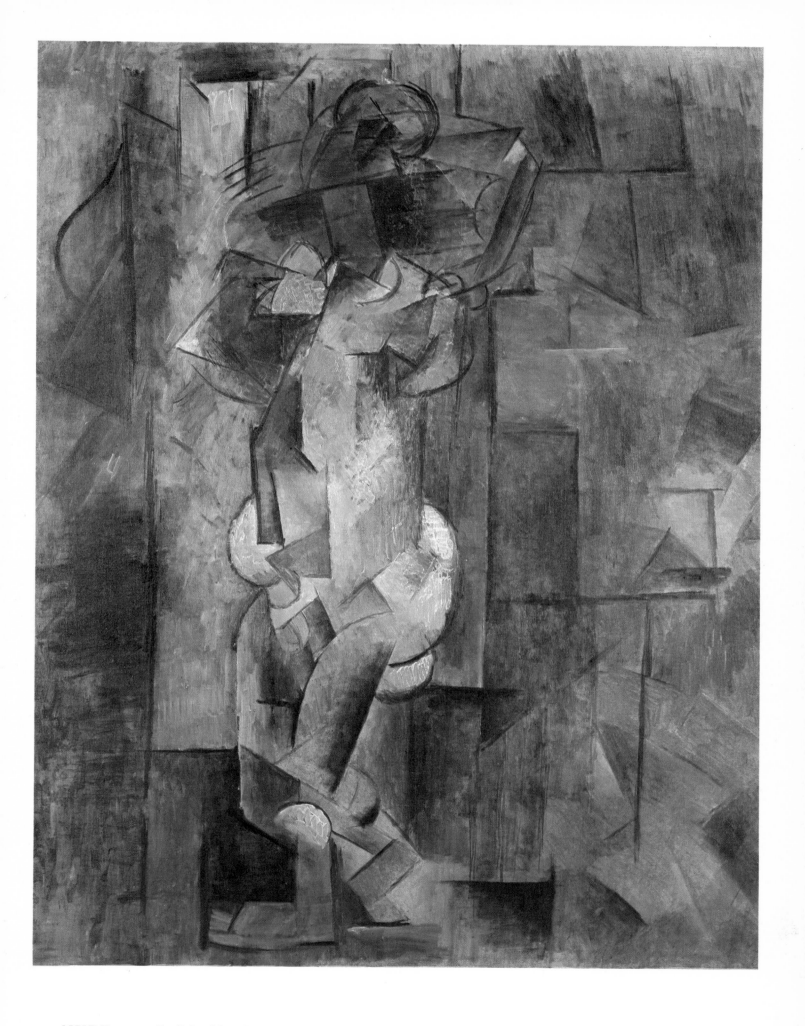

19. *NUDE*. 1910. Buffalo, New York, Albright-Knox Art Gallery

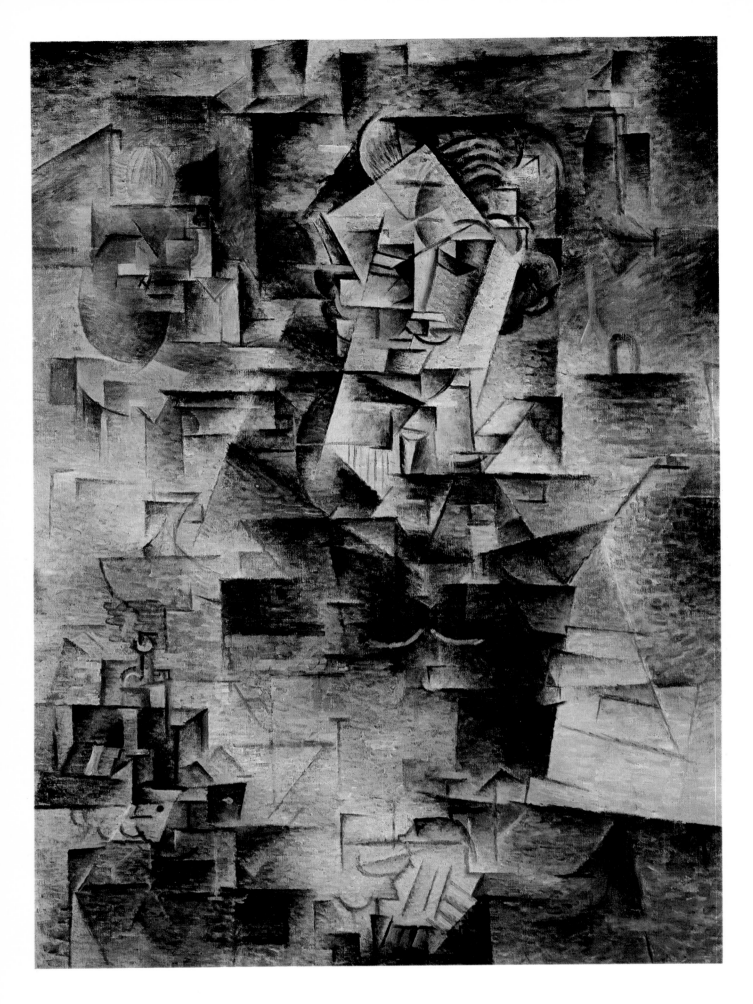

20. *DANIEL-HENRY KAHNWEILER.* 1910.
Chicago, Art Institute (Gift of Mrs. Gilbert W. Chapman)

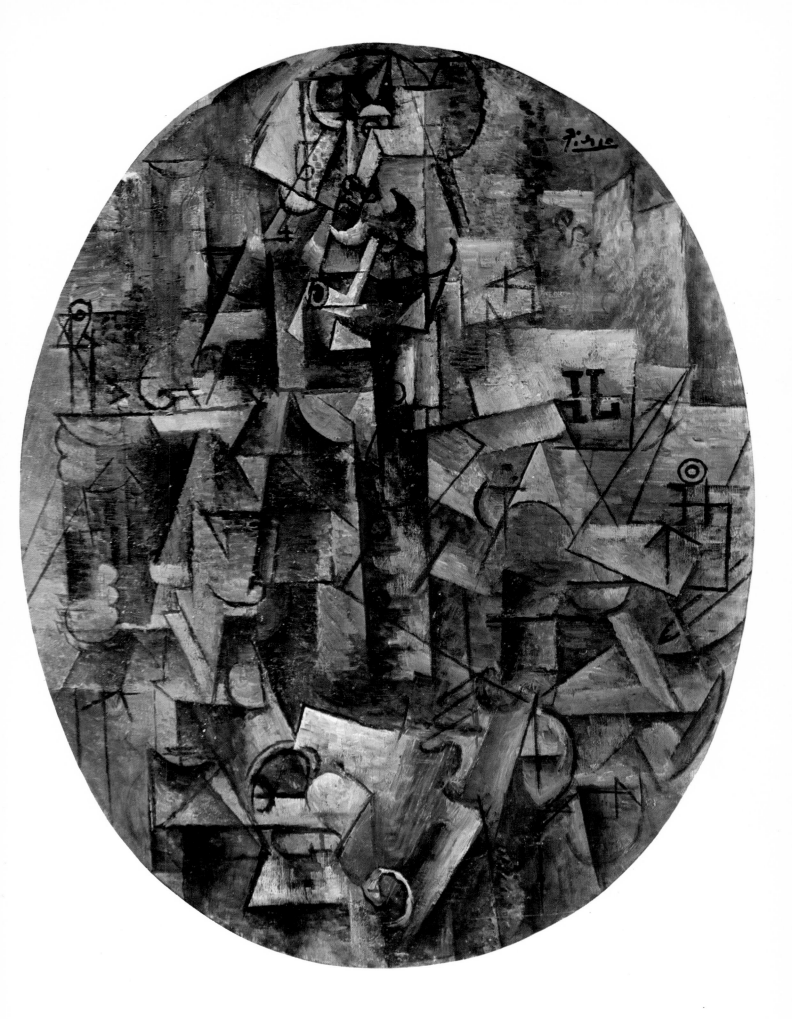

21. *MAN WITH A PIPE*. 1911. Fort Worth, Texas, The Kimbell Art Foundation

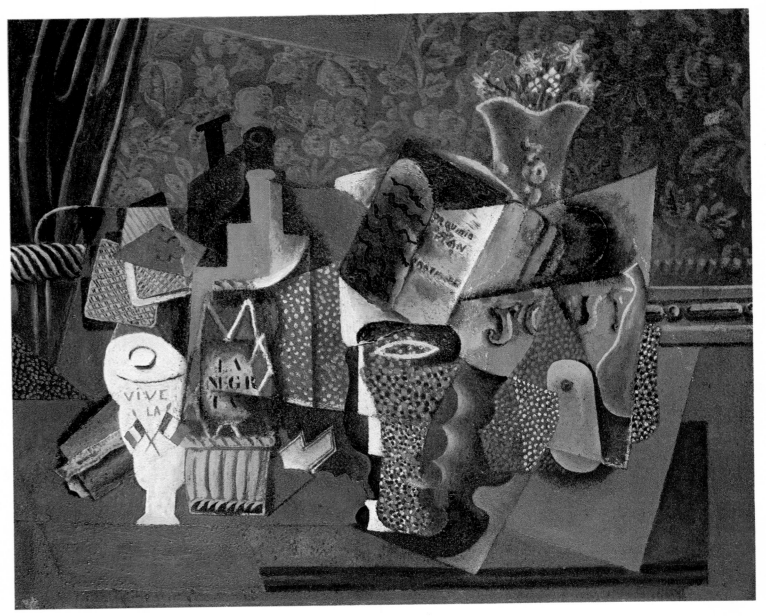

22. *VIVE LA FRANCE.* 1914. Chicago, Illinois, Mr. and Mrs. Leigh B. Block

23. *FRUIT-DISH, BOTTLE AND GUITAR.* 1914. Private Collection

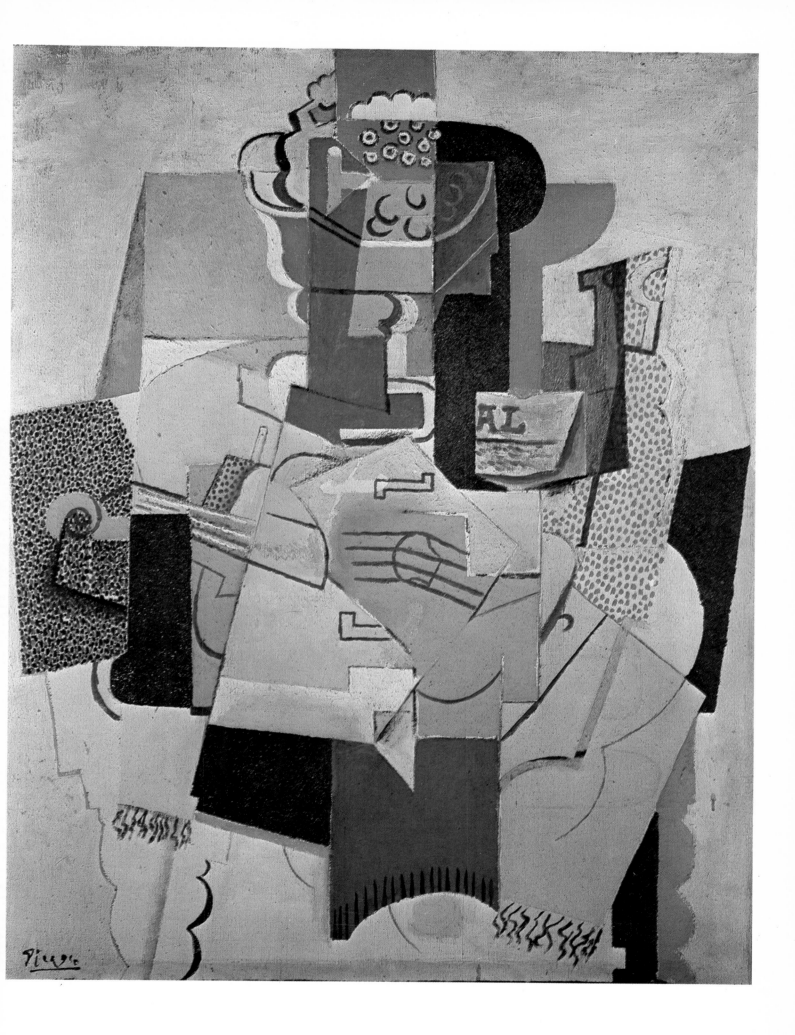

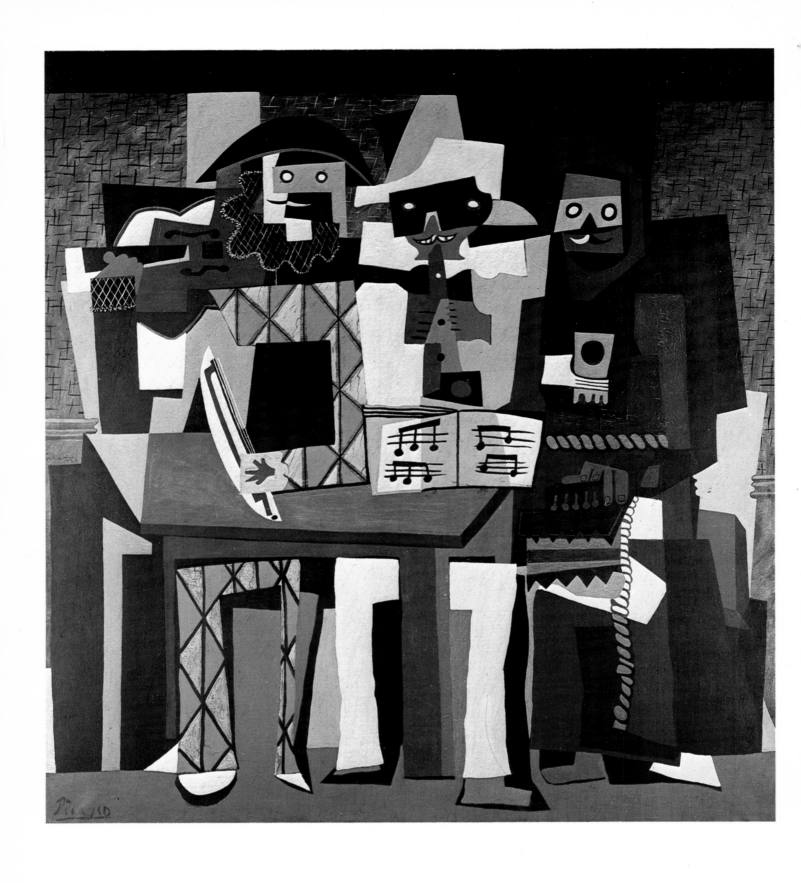

24. *THREE MASKED MUSICIANS*. 1921. Philadelphia, Museum of Art (Gallatin Collection)

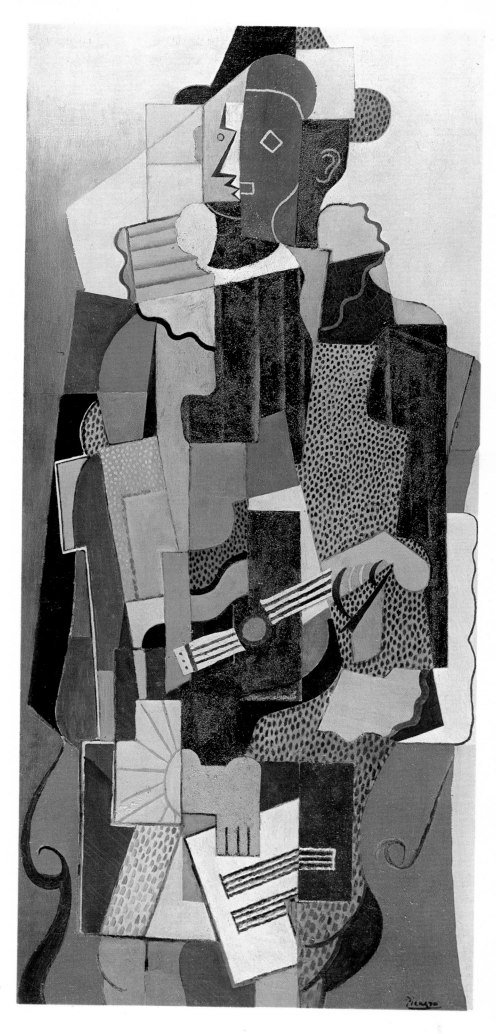

25. *HARLEQUIN*. 1918. St. Louis,
Missouri, Joseph Pulitzer

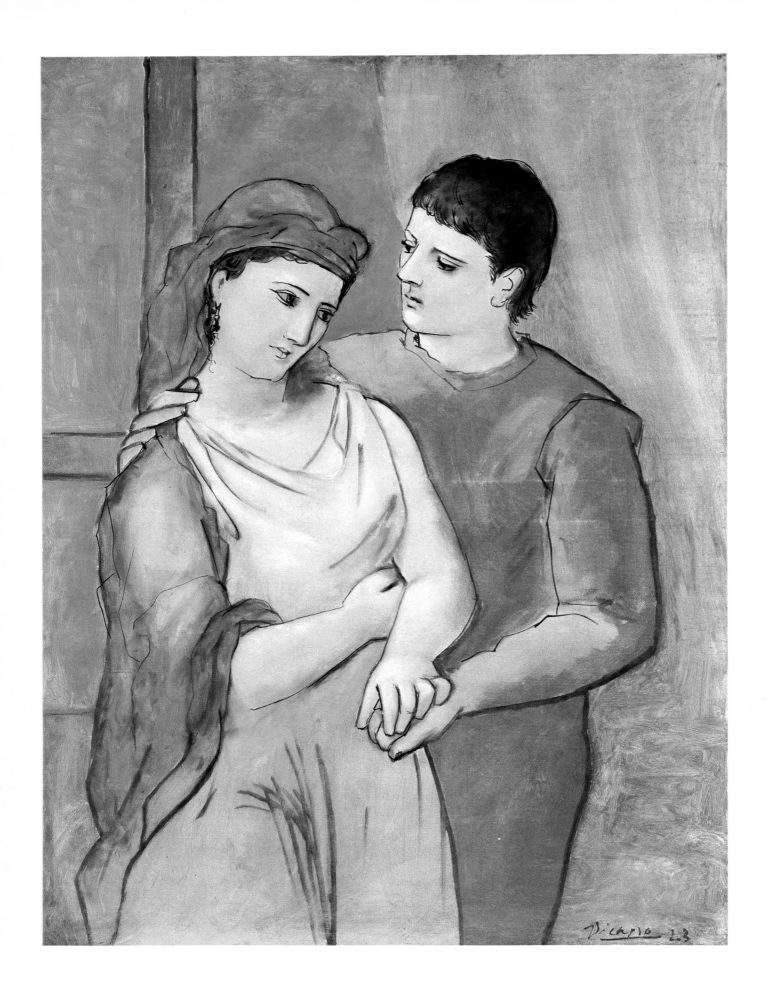

26. *THE LOVERS*. 1923. Washington, D.C., National Gallery of Art (Chester Dale Collection)

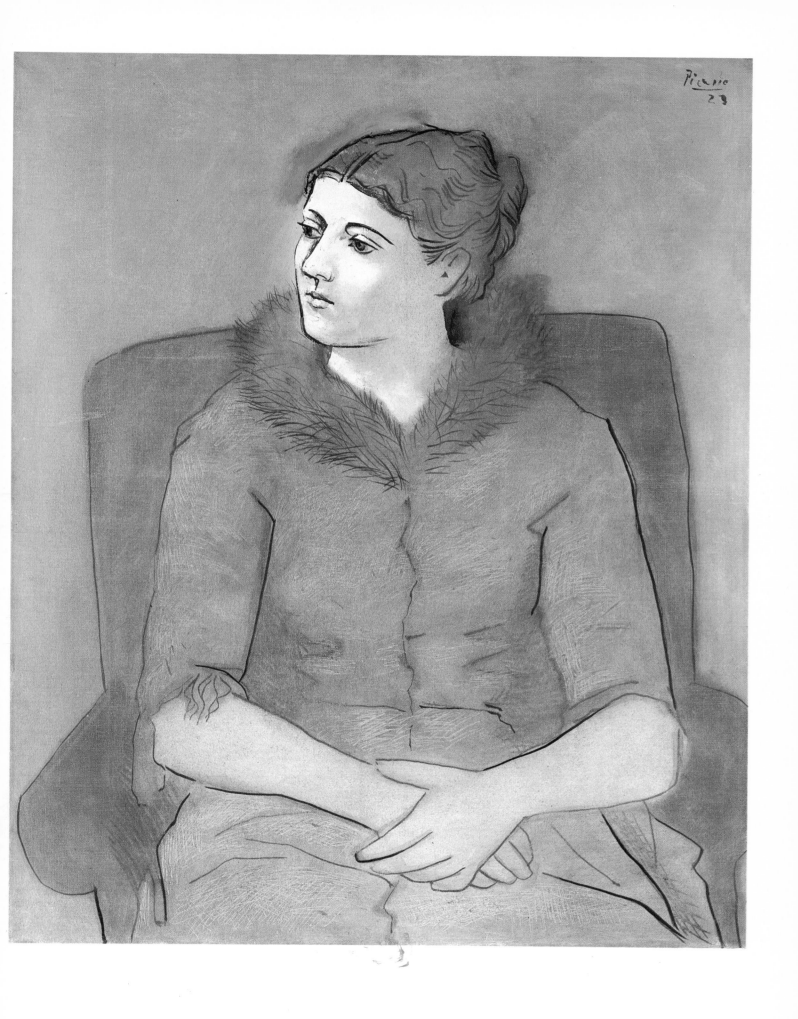

27. *MADAME PICASSO*. 1923. Washington, D.C., National Gallery of Art (Chester Dale Collection)

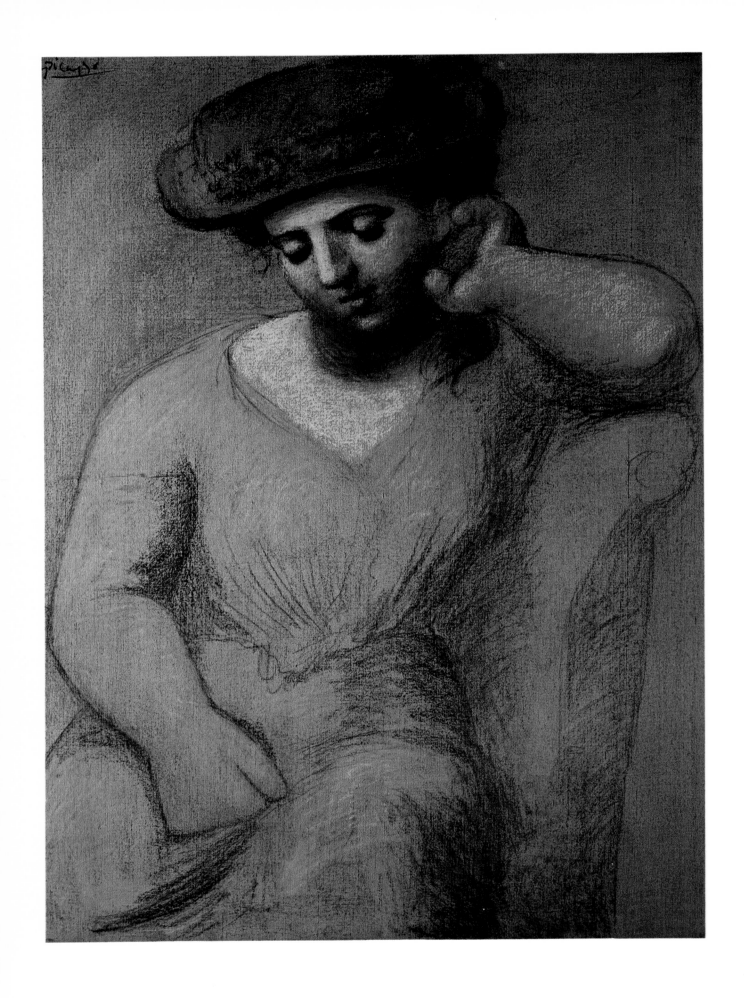

28. *WOMAN IN A BLUE HAT*. 1923. London, Tate Gallery (on loan from the James Foundation)

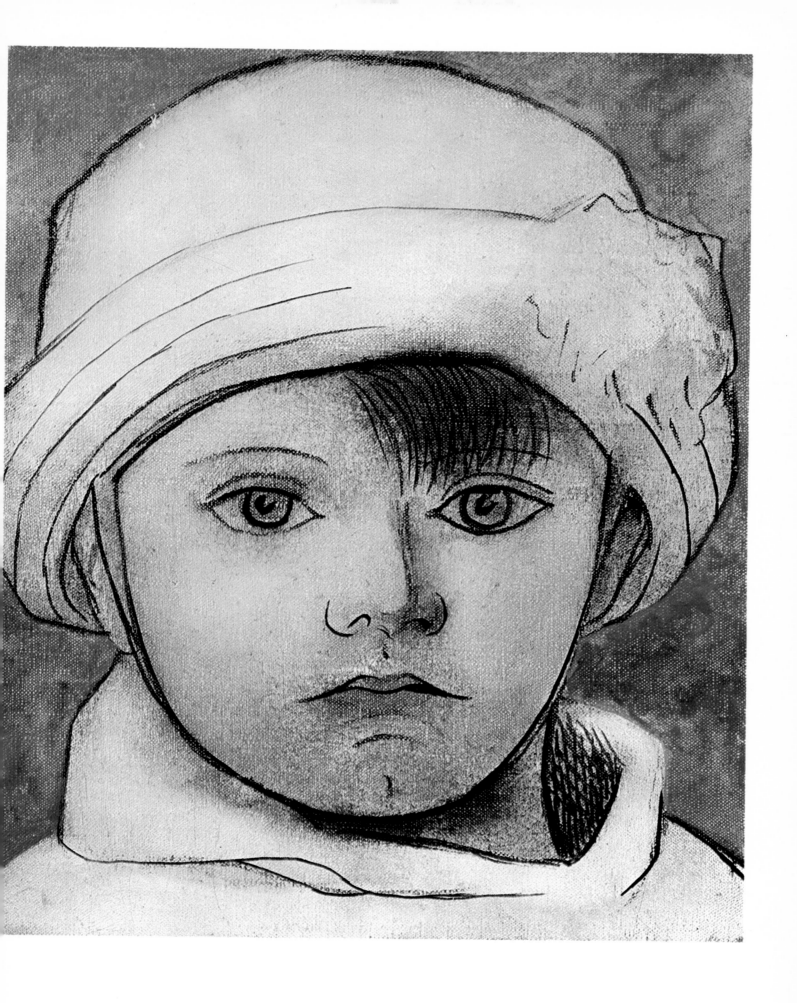

9. *HEAD OF PAUL*. 1923. Collection of the Artist

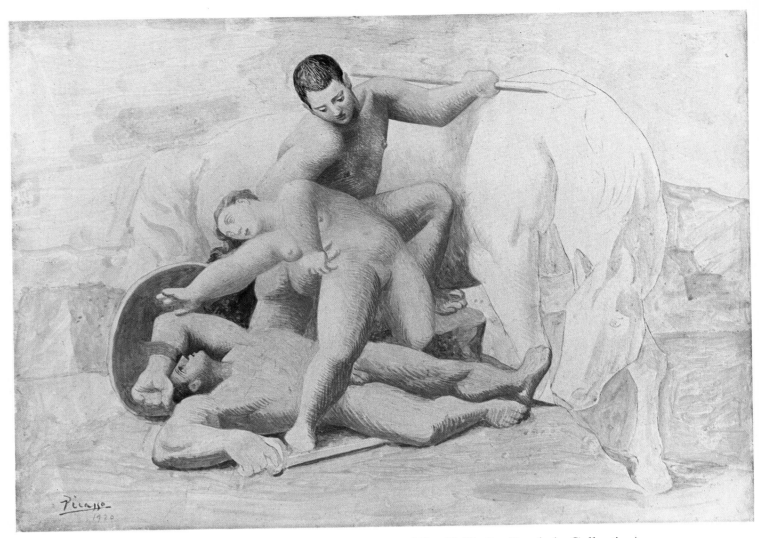

30. *THE RAPE*. 1920. New York, Museum of Modern Art (The Philip L. Goodwin Collection)

31. *THE THREE DANCERS*. 1925. London, Tate Gallery

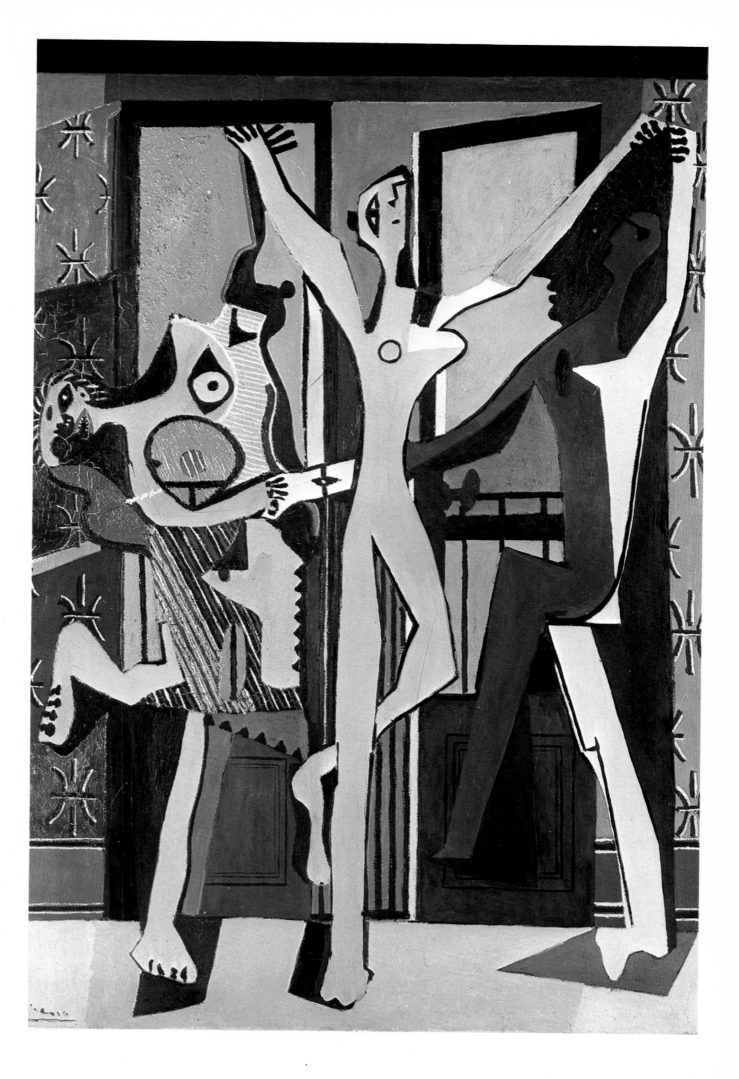

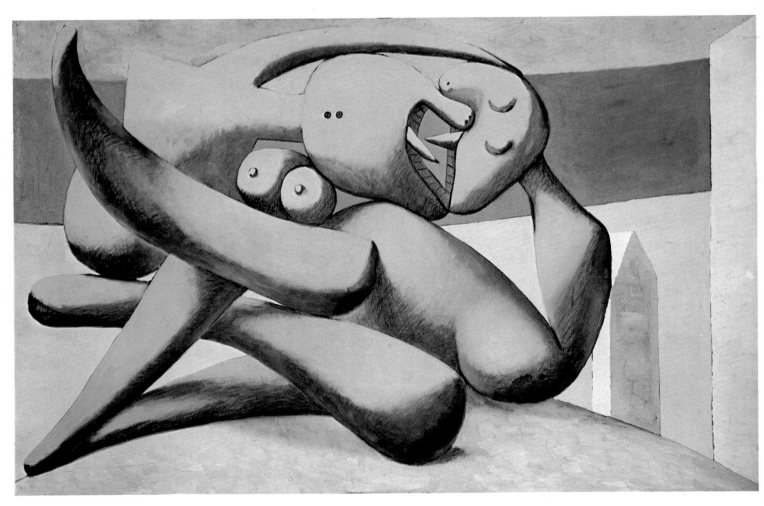

32. *FIGURES BY THE SEA.* 1931. Private Collection

33. *SEATED BATHER.* 1930. New York, Museum of Modern Art

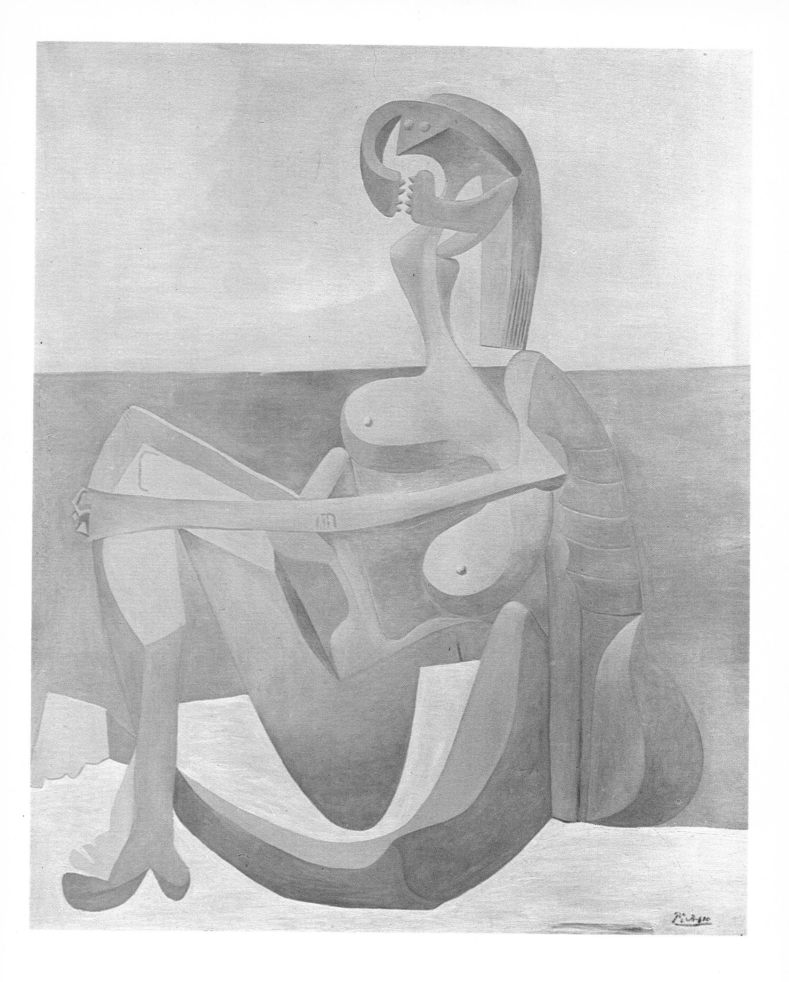

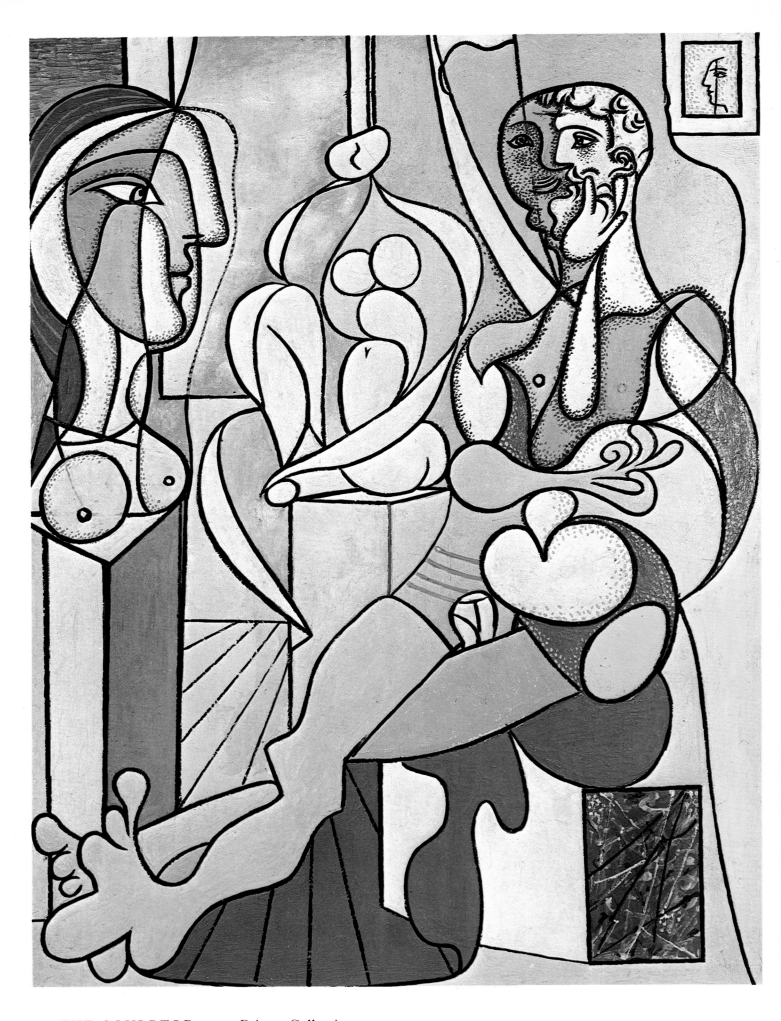

34. *THE SCULPTOR*. 1931. Private Collection

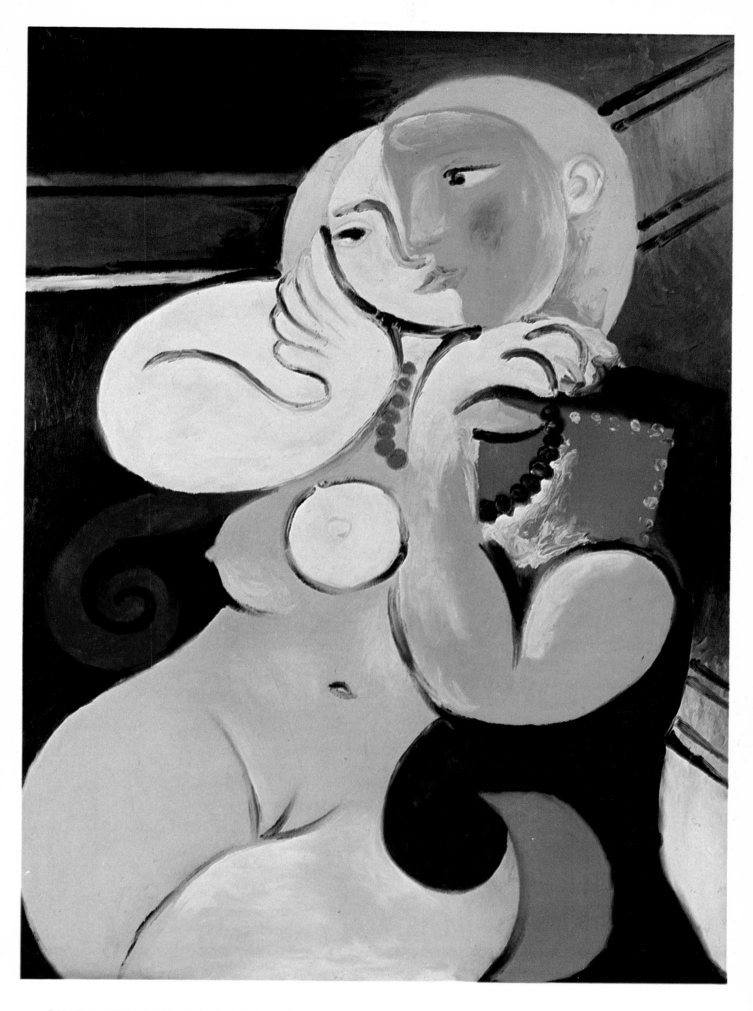

35. *NUDE WOMAN IN A RED ARMCHAIR.* 1932. London, Tate Gallery

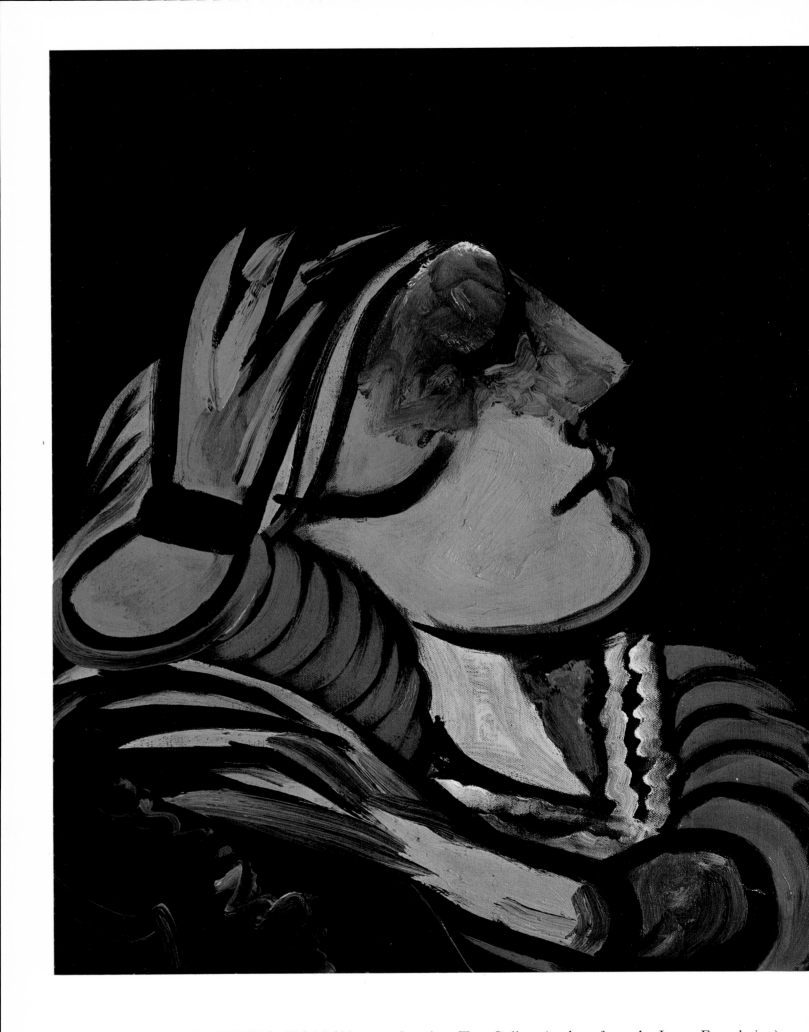

36. *HEAD OF A SLEEPING WOMAN*. 1932. London, Tate Gallery (on loan from the James Foundation)

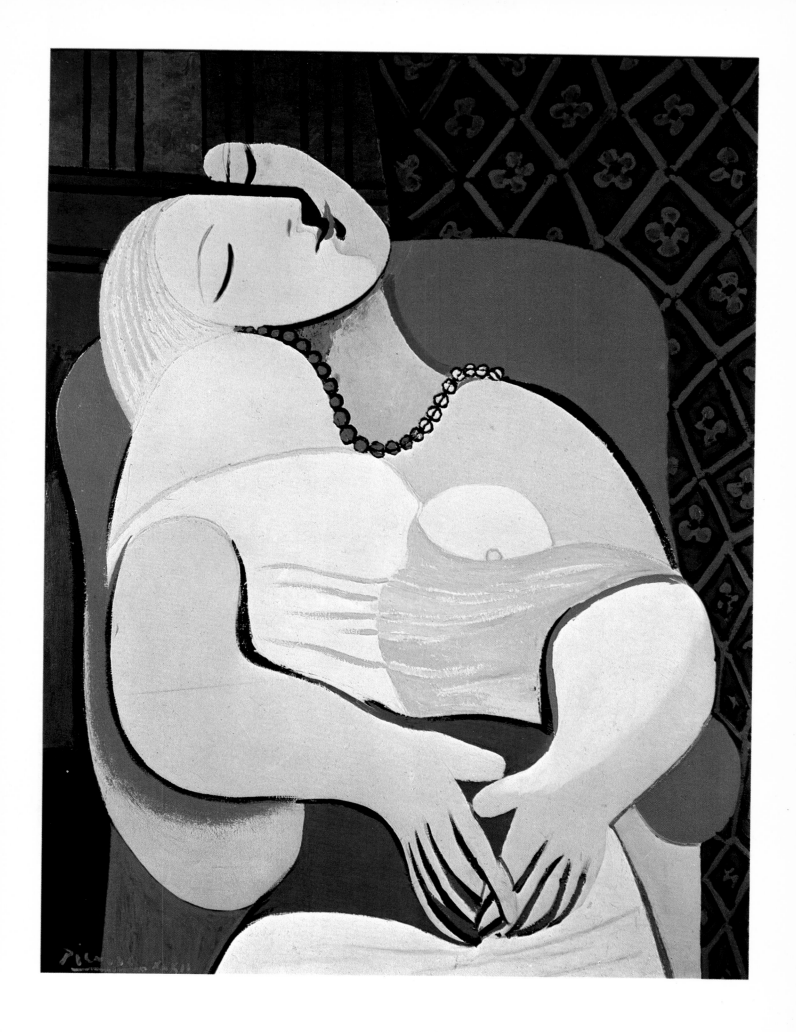

37. *WOMAN ASLEEP IN AN ARMCHAIR (LE RÊVE)*. 1932. New York, Private Collection

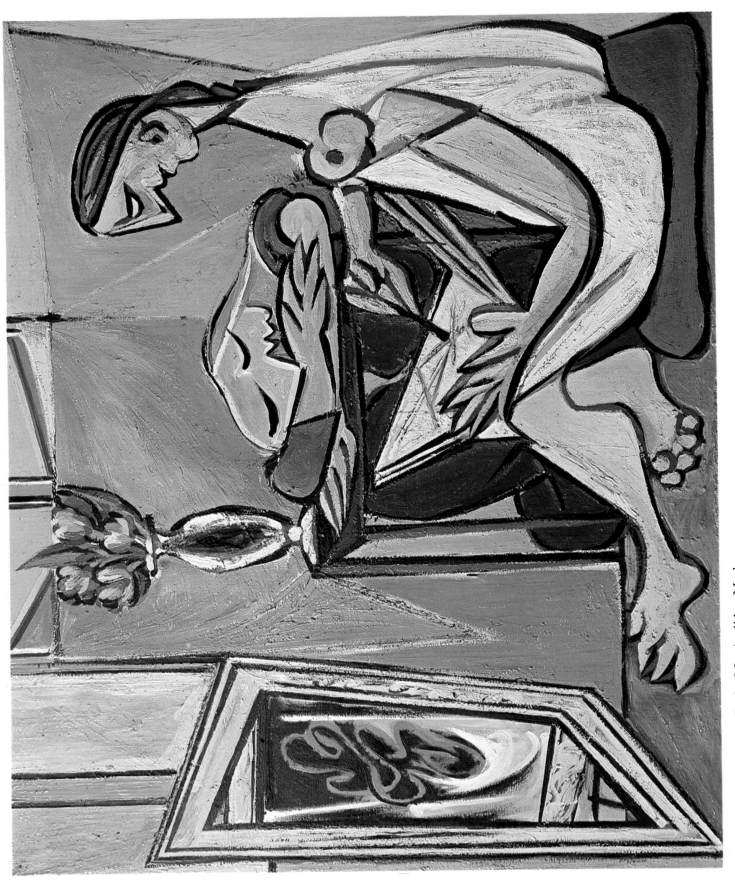

38. *LA MUSE.* 1935. Paris, Musée d'Art Moderne

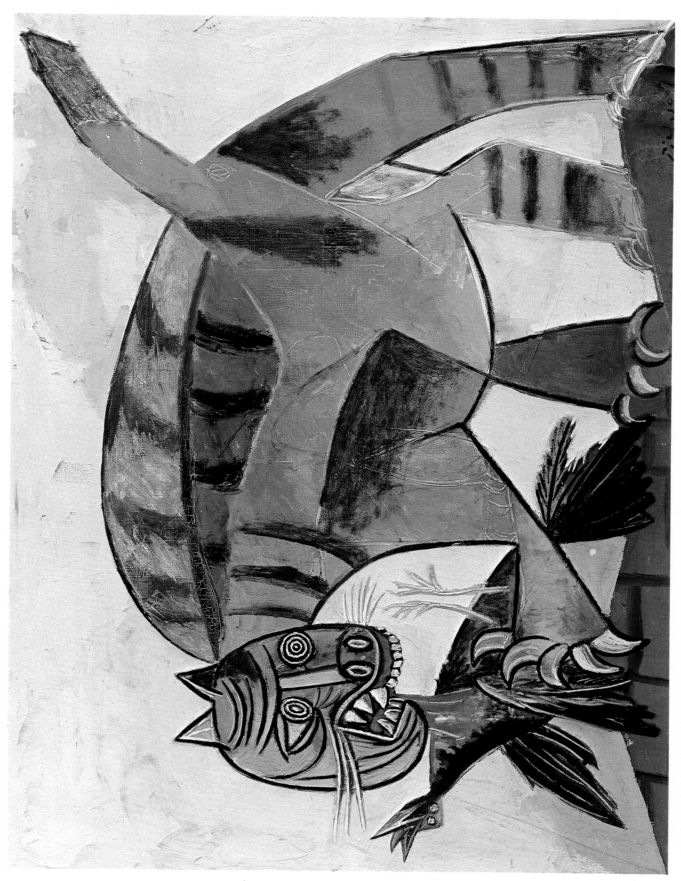

39. *CAT DEVOURING A BIRD.* 1939. New York, Private Collection

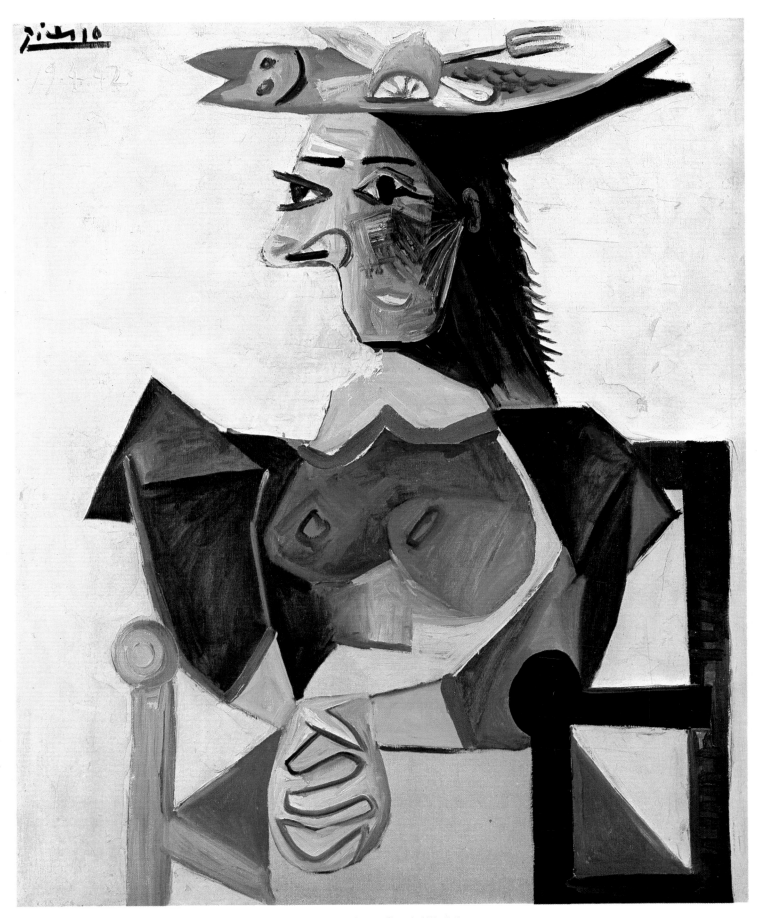

40. *WOMAN IN A FISH HAT*. 1942. Amsterdam, Stedelijk Museum

41. *DORA MAAR*. 1938. London, Tate Gallery

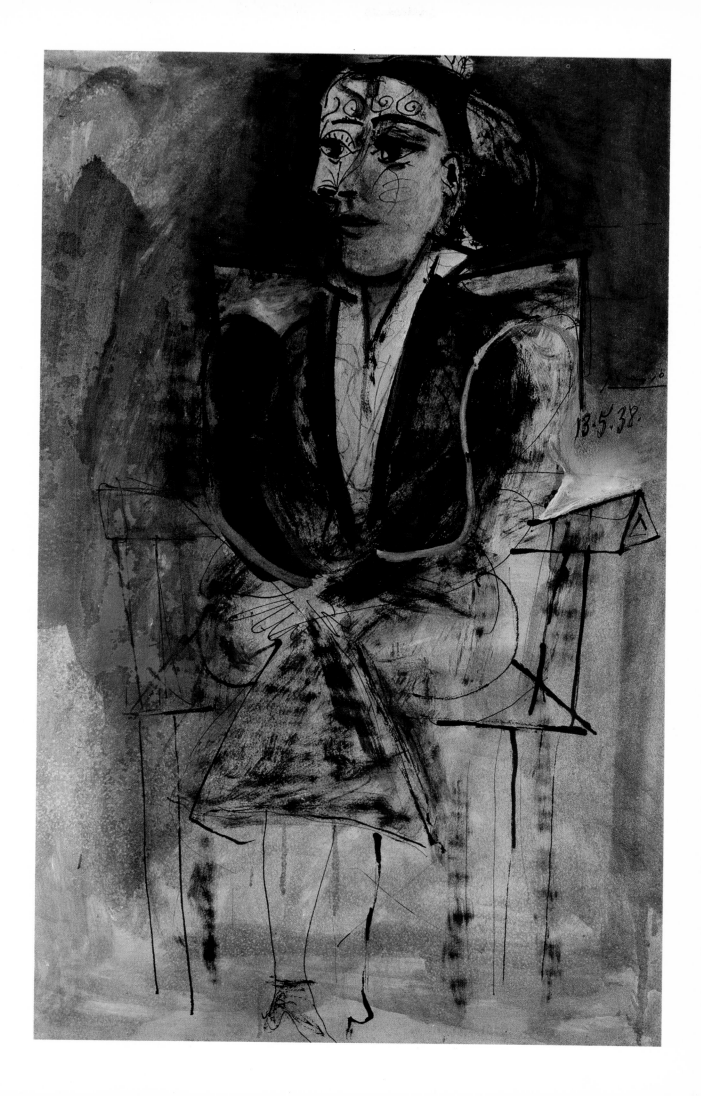

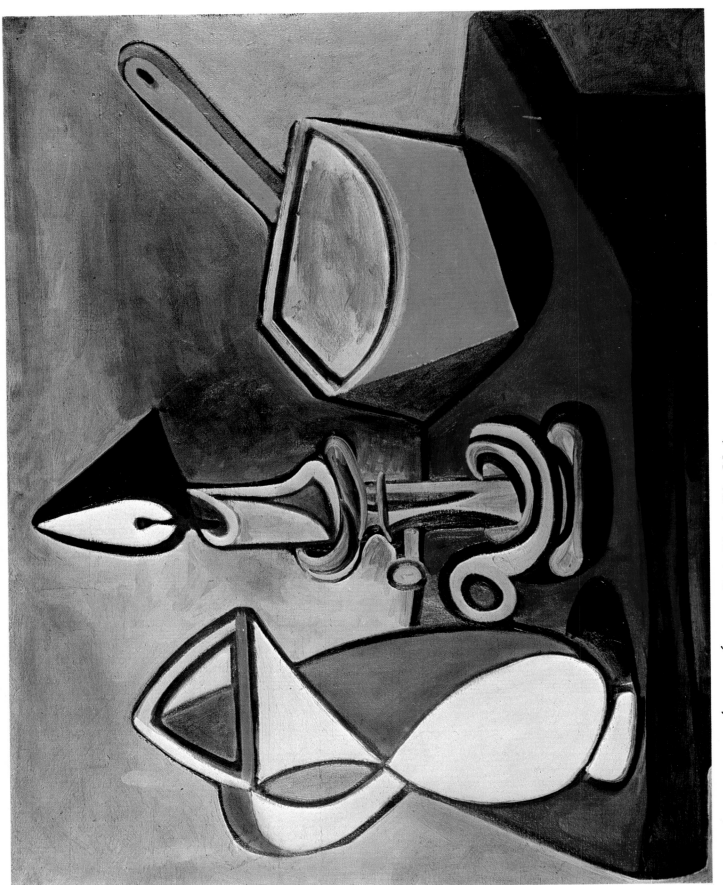

42. *LA CASSEROLE ÉMAILLÉE.* 1945. Paris, Musée d'Art Moderne

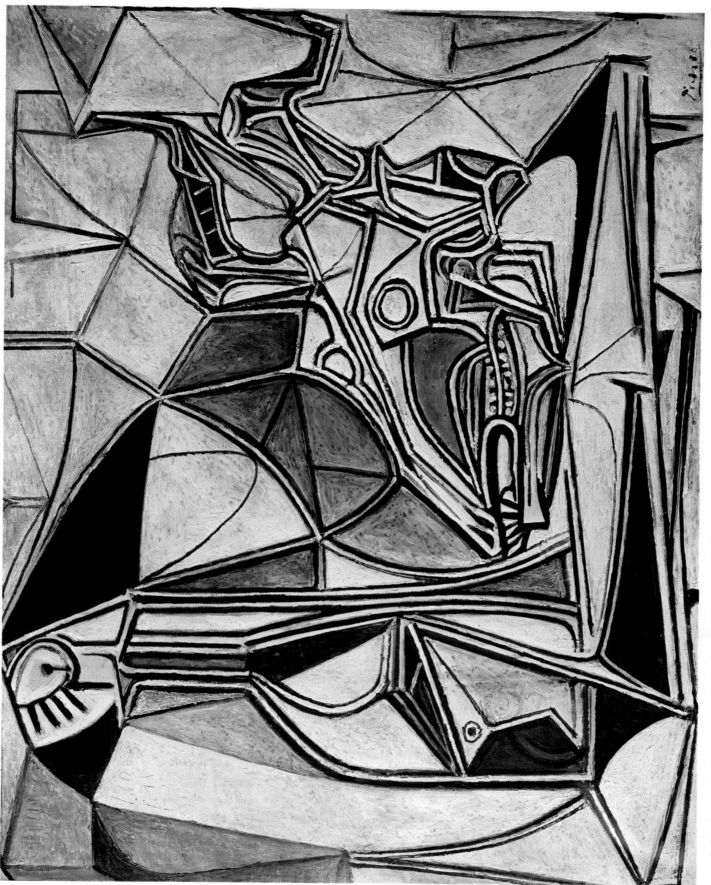

43. *GOAT'S SKULL, BOTTLE AND CANDLE.* 1952. London, Tate Gallery

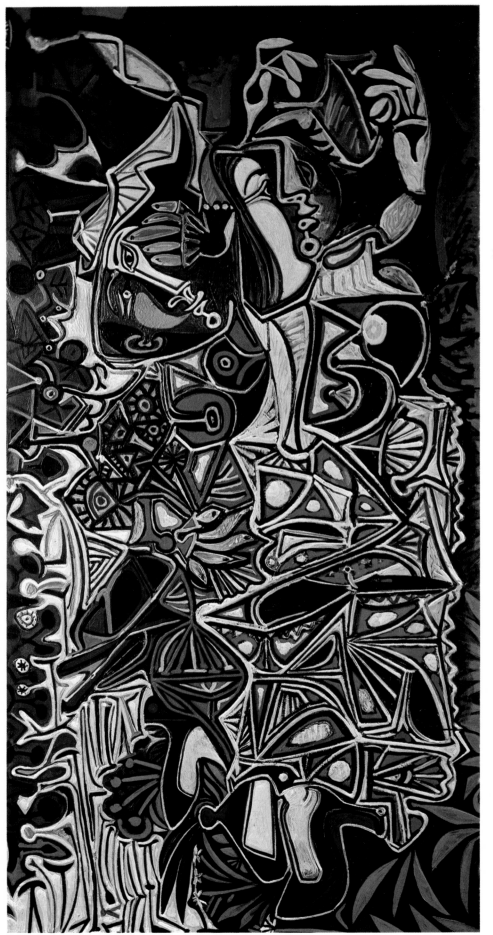

44. *LES DEMOISELLES DES BORDS DE LA SEINE* (free variation after Courbet). 1950. Basle, Kunstmuseum

45. *LES FEMMES D'ALGER* (free variation after Delacroix). 1955. Collection of the Artist

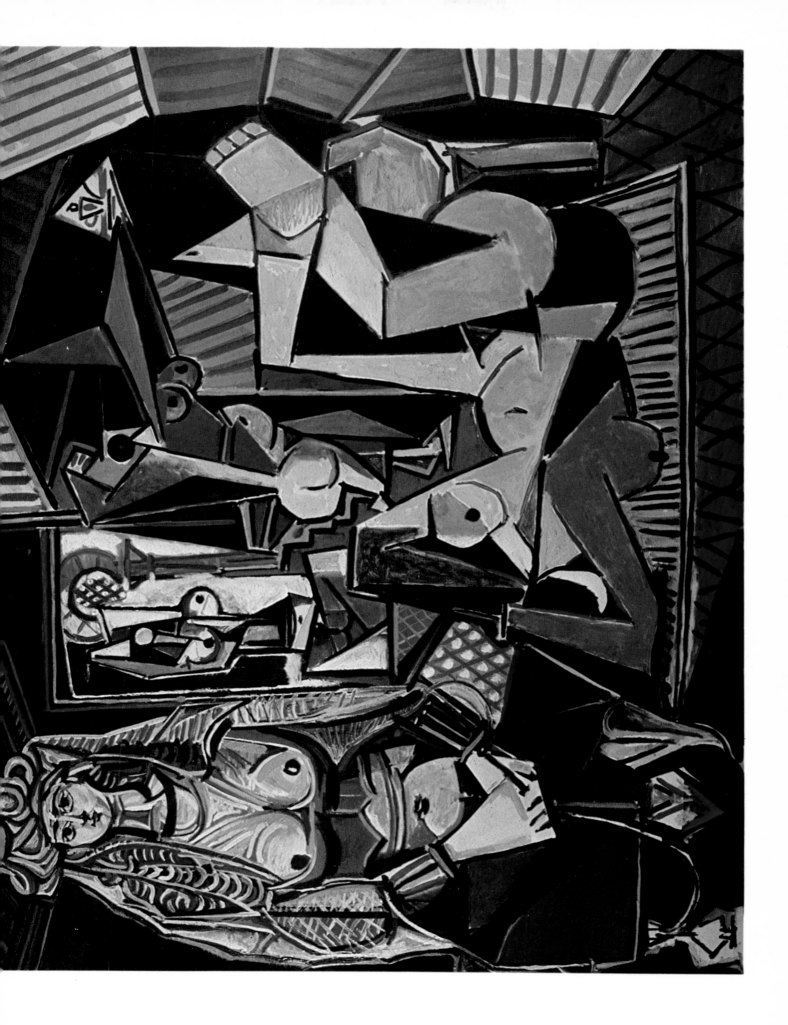

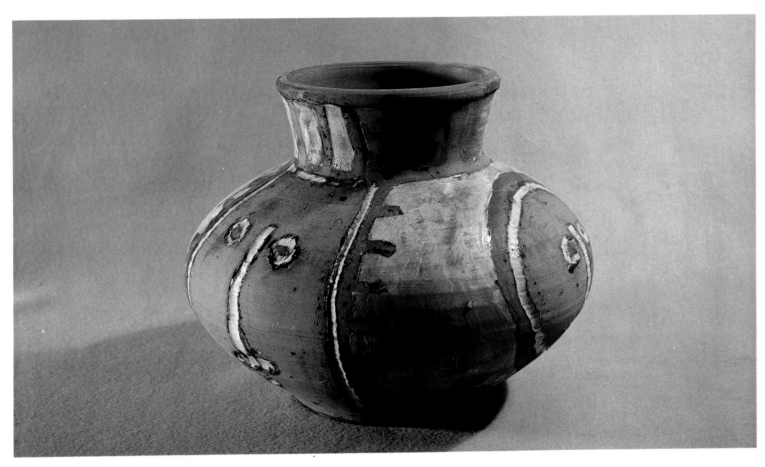

46a. Ceramic Pot

46b. Ceramic Plate, decorated with a design showing a man fighting a centaur

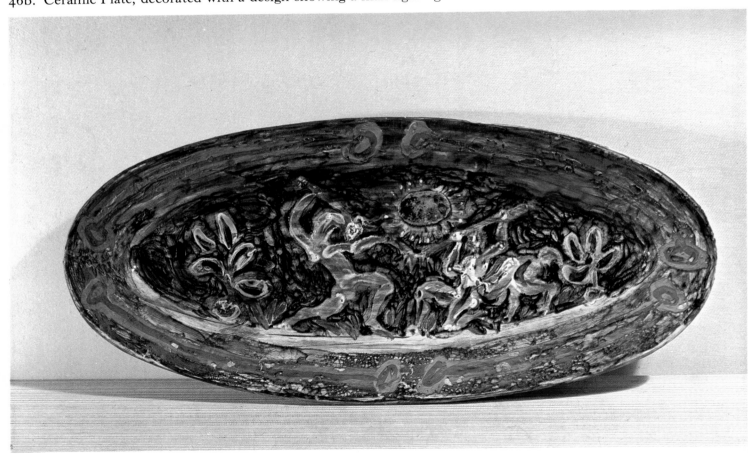

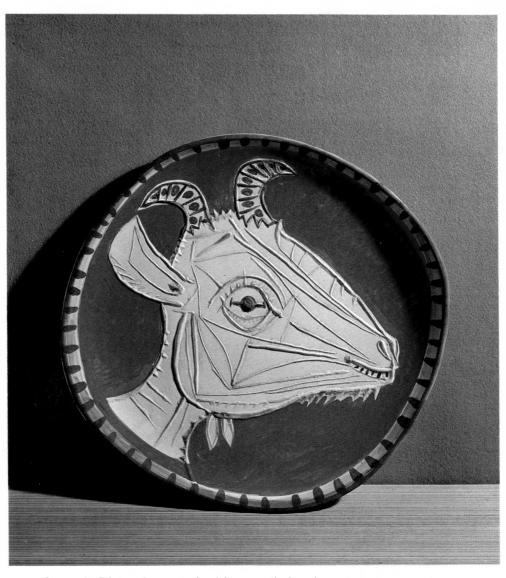

47a. Ceramic Plate, decorated with a goat's head

47b. *SPRING*. 1956. Paris, Private Collection

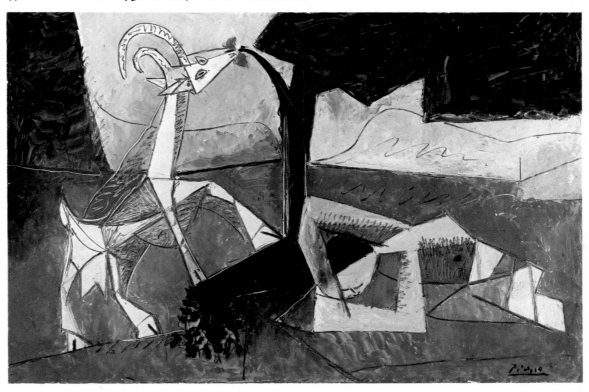

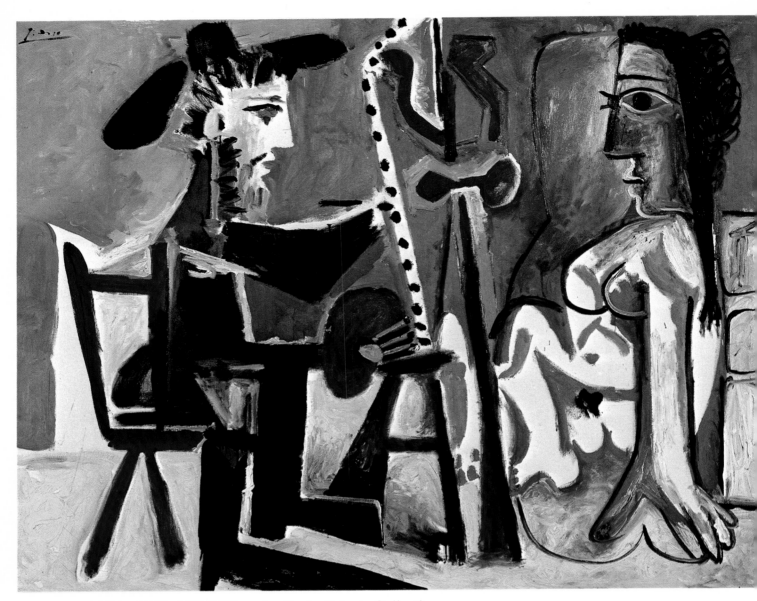

48. *PAINTER AND MODEL*. 1963. Paris, Private Collection